SHENZHEN

SHENZHEN

A TRAVELOGUE FROM CHINA

GUY DELISLE

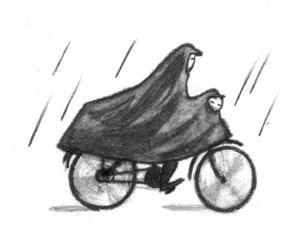

JONATHAN CAPE
LONDON

Published by Jonathan Cape 2006

2 4 6 8 10 9 7 5 3

Originally published in France by L'Association

L'Association

First English-language edition published in Canada by Drawn & Quarterly

Hand-lettered by Dirk Rehm
Publication design: Guy Delisle and Tom Devlin

First published in Great Britain in 2006 by
Jonathan Cape
Random House, 20 Vauxhall Bridge Road,
London SW1V 2SA

Random House Australia (Pty) Limited
20 Alfred Street, Milsons Point, Sydney,
New South Wales 2061, Australia

Random House New Zealand Limited
18 Poland Road, Glenfield,
Auckland 10, New Zealand

Random House (Pty) Limited
Isle of Houghton, Corner of Boundary Road & Carse O'Gowrie,
Houghton 2198, South Africa

Random House Publishers India Private Limited
301 World Trade Tower, Hotel Intercontinental Grand Complex,
Barakhamba Lane, New Delhi 110 001, India

The Random House Group Limited Reg. No. 954009
www.randomhouse.co.uk

A CIP catalogue record for this book is available from the British Library

ISBN 9780224079914 (from Jan 2007)
ISBN 0224079913

Papers used by Random House are natural,
recyclable products made from wood grown in sustainable forests.
The manufacturing processes conform to the environmental
regulations of the country of origin

Printed and bound in India by Replika Press Pvt. Ltd.

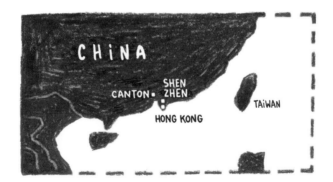

CHINA

CANTON • SHEN ZHEN

HONG KONG

TAIWAN

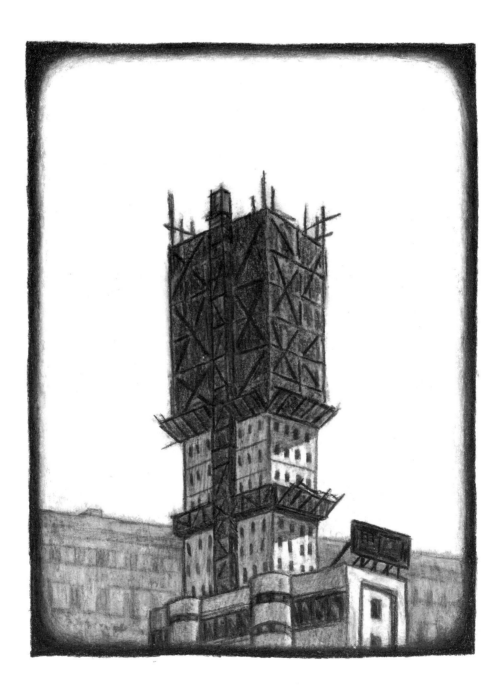

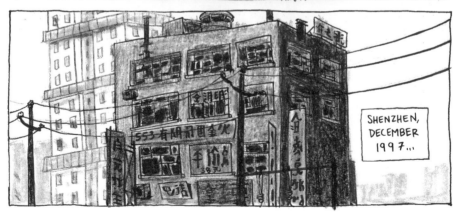

SHENZHEN,
DECEMBER
1997...

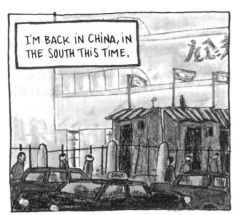

I'M BACK IN CHINA, IN THE SOUTH THIS TIME.

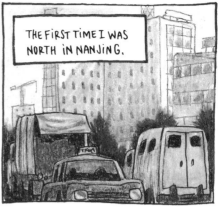

THE FIRST TIME I WAS NORTH IN NANJING.

I REDISCOVER WHAT I'D FORGOTTEN: THE SMELLS, THE NOISE, THE CROWDS, THE DIRT EVERYWHERE.

I REALIZE THAT I'D REMEMBERED ONLY THE GOOD THINGS... HOW EXOTIC IT WAS...

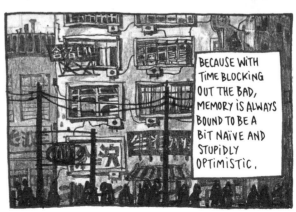

BECAUSE WITH TIME BLOCKING OUT THE BAD, MEMORY IS ALWAYS BOUND TO BE A BIT NAÏVE AND STUPIDLY OPTIMISTIC.

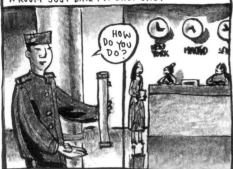

I'LL BE LIVING IN A HOTEL FOR THREE MONTHS, IN A ROOM JUST LIKE MY LAST ONE.

HOW DO YOU DO?

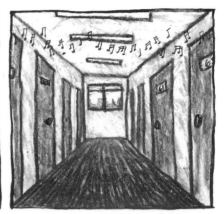

IN FACT, THERE IS ONLY ONE KIND OF HOTEL ROOM IN CHINA...

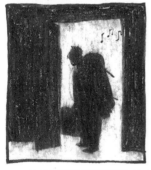

Zong Shan Hotel, Nanjing.

Great Wall Hotel, Shenzhen.

Holiday Inn, Canton.

Oriental Regent, Shanghai.

Victoria Hotel Canton.

HOT WATER FOR TEA OR SOUP.

THE SPOUT IS BADLY DESIGNED, SO WATER DRIBBLES EVERYWHERE.

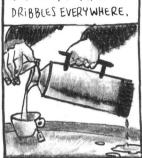

AND ALWAYS, A PANEL OF BUTTONS BETWEEN THE TWO BEDS TO CONTROL YOUR LITTLE UNIVERSE.

ON THE FIRST MORNING, I HAVE TO GET TO THE STUDIO TO MEET THE DIRECTOR I'LL BE REPLACING.

I ORDER A COFFEE AT THE HOTEL BAR. $3.50...

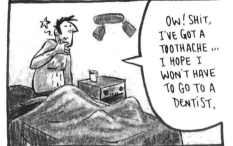

OW! SHIT, I'VE GOT A TOOTHACHE ... I HOPE I WON'T HAVE TO GO TO A DENTIST.

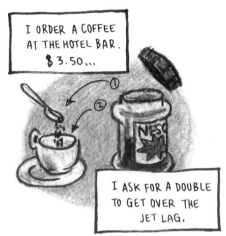

I ASK FOR A DOUBLE TO GET OVER THE JET LAG.

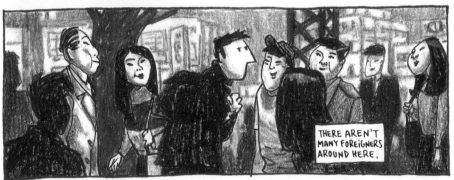

THERE AREN'T MANY FOREIGNERS AROUND HERE.

AFTER 8 MONTHS, THE DIRECTOR HAS PRETTY MUCH HAD IT. HE CAN'T WAIT TO CLEAR OUT.

THIS STUDIO IS A FRIGGIN' HOLE!

THE TRANSLATOR IS DEPRESSING AS ALL HELL, PLUS SHE DOESN'T KNOW A THING ABOUT ANIMATION...

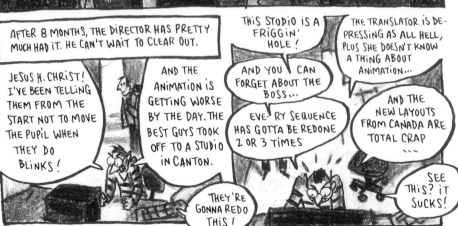

JESUS H. CHRIST! I'VE BEEN TELLING THEM FROM THE START NOT TO MOVE THE PUPIL WHEN THEY DO BLINKS!

AND THE ANIMATION IS GETTING WORSE BY THE DAY. THE BEST GUYS TOOK OFF TO A STUDIO IN CANTON.

AND YOU CAN FORGET ABOUT THE BOSS...

EVE-RY SEQUENCE HAS GOTTA BE REDONE 2 OR 3 TIMES

AND THE NEW LAYOUTS FROM CANADA ARE TOTAL CRAP ...

THEY'RE GONNA REDO THIS!

SEE THIS? IT SUCKS!

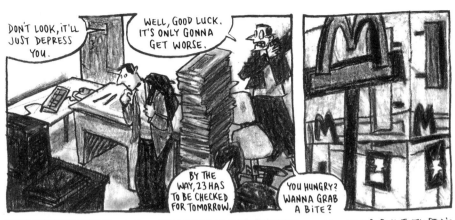

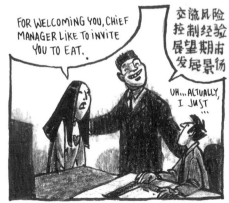

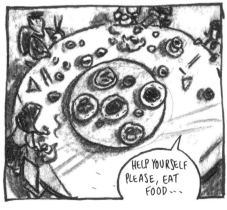

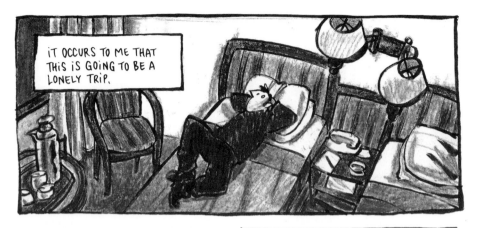

IT OCCURS TO ME THAT THIS IS GOING TO BE A LONELY TRIP.

FOR A MODERN CITY NEXT TO HONG KONG, SHENZHEN HAS VERY FEW BILINGUAL CHINESE...

THERE'S NO UNIVERSITY OR CAFÉ FOR ME TO MEET YOUNG PEOPLE INTERESTED IN THE WEST.

PEOPLE COME HERE TO DO BUSINESS. AFTER A DAY OR TWO OF MEETINGS, THEY HEAD BACK TO HONG KONG.

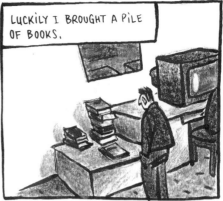

LUCKILY I BROUGHT A PILE OF BOOKS.

Until then,
keep your chin up,
forget your sensitivities
and observe people,
especially those nearest you.
You'll enjoy it.
I guarantee that you're in
for a pleasant surprise.

from the novel *Carrot Top*
by Jules Renard

Hmm
...

ONE DAY OVER LUNCH, I TRY TO GET TO KNOW MY TRANSLATOR.

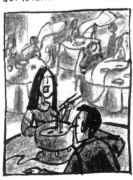

WHAT KIND OF MEAT IS THIS? OH, OK, I SEE.

AFTER THE MEAL, SHE COVERS HER MOUTH WITH ONE HAND WHILE USING HER TOOTHPICK.

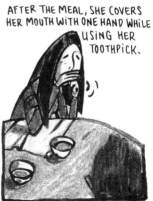

SHE DIDN'T ASK A SINGLE QUESTION ALL THROUGH THE MEAL. I WAS MORE INQUISITIVE AND TRIED TO LIVEN THINGS UP.

WHAT KIND OF BOOKS DO YOU LIKE TO READ?

YES, VERY MUCH!

OK, LET'S SEE... TODAY IS THE 27TH... I ARRIVED ON THE 24TH... I'M LEAVING AT THE END OF FEBRUARY... THAT MEANS I'VE ONLY GOT ANOTHER...

HELLO!

HOW OLD ARE YOU?

14

THE FIRST FEW NIGHTS, I CAN'T SLEEP.

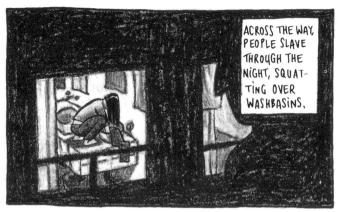
ACROSS THE WAY, PEOPLE SLAVE THROUGH THE NIGHT, SQUATTING OVER WASHBASINS.

WEEKS LATER, I REALIZE IT'S THE HOTEL LAUNDRY SERVICE.

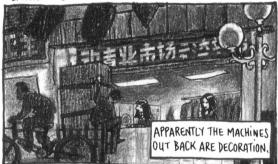
APPARENTLY THE MACHINES OUT BACK ARE DECORATION.

HAVING A PAIR OF BOXERS WASHED COSTS AS MUCH AS A MEAL IN THE STREET.

HOTEL FOOD IS MORE EXPENSIVE, OF COURSE, BUT YOU GET SERVICE (TOO MUCH FOR MY TASTE). IN GENERAL, THE MORE WAITRESSES THERE ARE, THE CLASSIER THE PLACE.

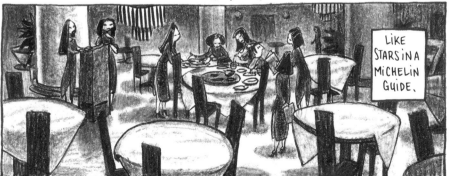
LIKE STARS IN A MICHELIN GUIDE.

AFTER EVERY SIP, MY CUP GETS A REFILL. THE CONSTANT ATTENTION IS DISTRACTING AT FIRST, BUT YOU LEARN TO IGNORE IT.
BECOMING BOURGEOIS MUST START LIKE THIS.

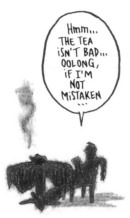

Hmm... THE TEA ISN'T BAD... OOLONG, IF I'M NOT MISTAKEN...

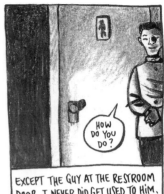

HOW DO YOU DO?

EXCEPT THE GUY AT THE RESTROOM DOOR. I NEVER DID GET USED TO HIM.

ON MY WAY DOWNTOWN TO THE BANK, I NOTICE A STRANGE BUILDING, SOME 15 STORIES HIGH WITH NO WINDOWS, A LARGE GRAY CONCRETE SLAB. BIZARRE.

DURING MY STAY, I LOOKED FOR THE STRANGE CUBE A FEW TIMES TO PHOTOGRAPH IT, BUT I NEVER FOUND IT AGAIN... IT HAD VANISHED.

IN THE CITY STREETS, CRIPPLES BEG BY KNOCKING THEIR FOREHEADS ON THE GROUND.

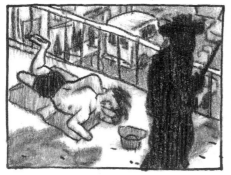

ACTUALLY, THEY'RE FAKING. THEY STOP BEFORE HITTING THE PAVEMENT, BUT WITH THEIR LONG HAIR YOU CAN'T TELL.

IF THEY WERE HITTING THE GROUND, YOU'D HEAR SOMETHING... BUT YOU DON'T.

OPPOSITE A CHEVIGNON STORE.

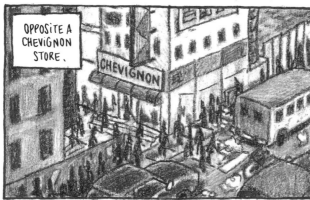

SHOPPING IS THE MAIN PASTIME HERE. IN FACT, IT'S THE ONLY PASTIME.

STRANGELY ENOUGH, ALL YOU SEE ARE BRAND NAMES, AND THEY'RE NOT CHEAPER HERE THAN ANYWHERE ELSE.

BUYING A ROLEX IS NO PROBLEM...

BUT SIMPLER THINGS ARE MORE DIFFICULT.

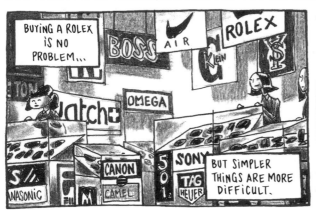

IT TOOK ME THREE DAYS TO FIND A STORE SELLING KITCHEN KNIVES SO I COULD CUT MY APPLES AT THE HOTEL.

AT THE BANK

STANDING IN LINE IS NOT A CLEAR CONCEPT IN CHINA. LEAVE A SPACE AND IT'S LIKELY TO BE FILLED.

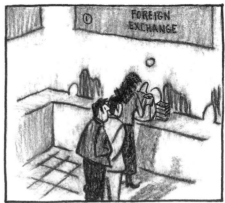

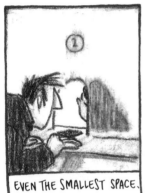

EVEN THE SMALLEST SPACE.

THE TELLER CLIPS TOGETHER MY PASSPORT, THE CASH AND A RECEIPT... AND BING!

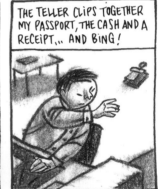

PLAC

A LITTLE RUBBER STAMP...

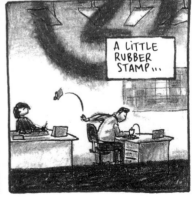

AND THERE... I GET MY MONEY.

THE TELLER USES A CANDY BOX FOR SMALL CHANGE.

NEXT TO ME, A GIRL PULLS BUND-LES OF BILLS OUT OF HER BAG!

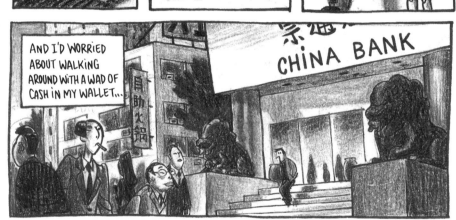
AND I'D WORRIED ABOUT WALKING AROUND WITH A WAD OF CASH IN MY WALLET...

CHINA BANK

FOR THE OPENING OF A KENTUCKY FRIED CHICKEN OUTLET, YOUNG UNIFORMED EMPLOYEES DO A LITTLE PROMOTIONAL DANCE NUMBER THAT HAS A MILITARY FEEL TO IT.

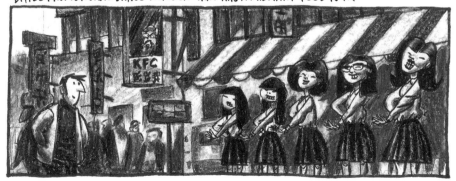

ANOTHER PLOY TO ATTRACT CLIENTS: LOUDSPEAKERS.

THAT EVENING, THE STUDIO'S ANIMATION DIRECTOR AND HIS BROTHER INVITE ME TO THE HARD ROCK CAFE FOR WESTERN FOOD.

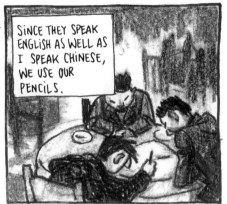

SINCE THEY SPEAK ENGLISH AS WELL AS I SPEAK CHINESE, WE USE OUR PENCILS.

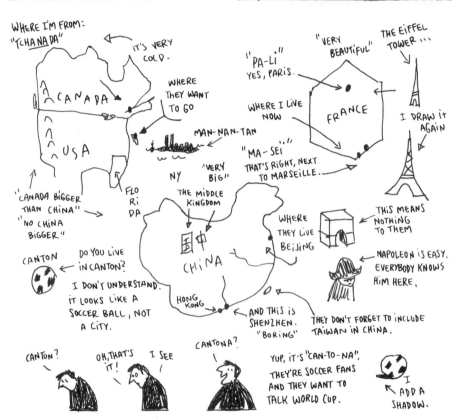

WHERE I'M FROM: "TCHANADA"

IT'S VERY COLD.

WHERE THEY WANT TO GO

CANADA

USA

"CANADA BIGGER THAN CHINA"
"NO CHINA BIGGER"

NY

FLO RI DA

MAN-NAN-TAN

"VERY BIG"

CANTON

DO YOU LIVE IN CANTON?

I DON'T UNDERSTAND. IT LOOKS LIKE A SOCCER BALL, NOT A CITY.

THE MIDDLE KINGDOM

国中

CHINA

HONG KONG

AND THIS IS SHENZHEN. "BORING"

"PA-LI" YES, PARIS.

"VERY BEAUTIFUL"

THE EIFFEL TOWER ...

WHERE I LIVE NOW

FRANCE

"MA-SEI" THAT'S RIGHT, NEXT TO MARSEILLE.

I DRAW IT AGAIN

THIS MEANS NOTHING TO THEM

WHERE THEY LIVE BEIJING

NAPOLEON IS EASY. EVERYBODY KNOWS HIM HERE.

THEY DON'T FORGET TO INCLUDE TAIWAN IN CHINA.

CANTON?

OH, THAT'S IT!

I SEE

CANTONA?

YUP, IT'S "CAN-TO-NA", THEY'RE SOCCER FANS AND THEY WANT TO TALK WORLD CUP.

I ADD A SHADOW.

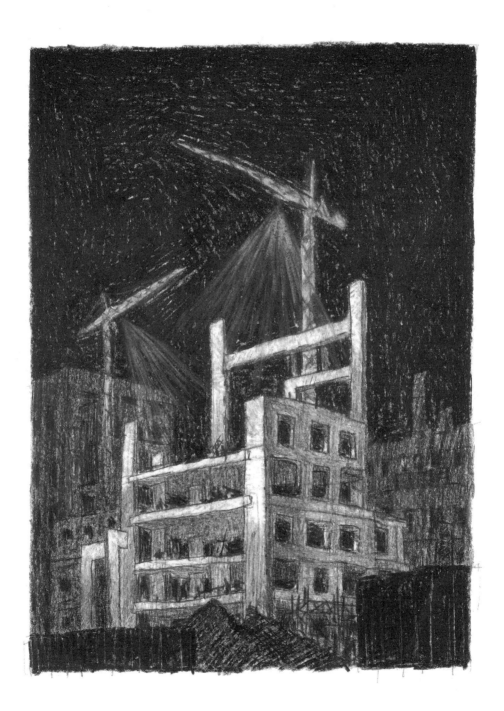

I TREAT MY TOOTHACHE WITH DENTAL FLOSS LEFT BEHIND BY THE LAST DIRECTOR. AN ESSENTIALLY NORTH AMERICAN PRACTICE, IT SHOULD SAVE ME FROM REPEATING THE LAST TRIP'S HARROWING VISIT TO THE DENTIST.

WHY SHOULDN'T I TRUST A CHINESE DENTIST?

I THOUGHT BACK THEN...

I'D HAD THE GREAT IDEA OF GETTING MY WISDOM TEETH PULLED SINCE THEY WERE CROWDING THE REST IN AN UNAESTHETIC WAY.

WANTING TO GET IT OVER WITH AND FEELING CONFIDENT, I FOLLOWED MY TRANSLATOR TO THE DENTAL CLINIC.

IT WAS PACKED...

SHE DISAPPEARED INTO THE CROWD AND CAME OUT WITH AN APPOINTMENT ON THE FIRST FLOOR.

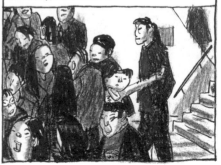

AT THE DOOR, ANOTHER CROWD. ONLOOKERS WERE WATCHING PATIENTS GETTING TREATED INSIDE.

MY TRANSLATOR PUSHED ME, AND I FOUND MYSELF IN FRONT OF ONE OF THE STRANGEST SIGHTS I'D EVER SEEN.

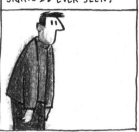

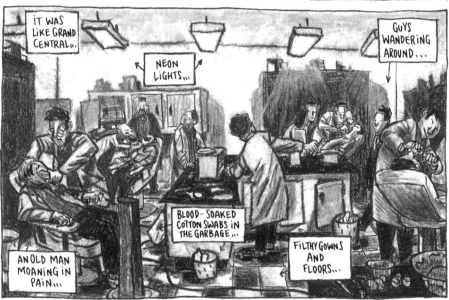

IT WAS LIKE GRAND CENTRAL...

NEON LIGHTS...

GUYS WANDERING AROUND...

BLOOD-SOAKED COTTON SWABS IN THE GARBAGE...

FILTHY GOWNS AND FLOORS...

AN OLD MAN MOANING IN PAIN...

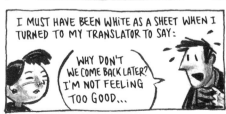

I MUST HAVE BEEN WHITE AS A SHEET WHEN I TURNED TO MY TRANSLATOR TO SAY:

WHY DON'T WE COME BACK LATER? I'M NOT FEELING TOO GOOD...

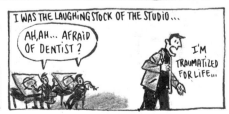

I WAS THE LAUGHING STOCK OF THE STUDIO...

AH, AH... AFRAID OF DENTIST?

I'M TRAUMATIZED FOR LIFE...

I DID GO BACK, BUT AT NIGHT WHEN THERE WERE FEWER PEOPLE AND WITH A FRIEND WHO SPOKE PERFECT CHINESE.

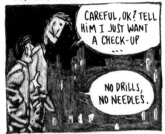

CAREFUL, OK? TELL HIM I JUST WANT A CHECK-UP ...

NO DRILLS, NO NEEDLES.

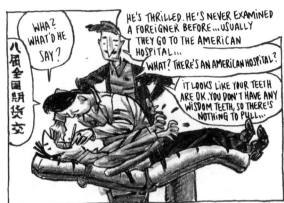

WHA? WHAT'D HE SAY?

HE'S THRILLED. HE'S NEVER EXAMINED A FOREIGNER BEFORE... USUALLY THEY GO TO THE AMERICAN HOSPITAL...

WHAT? THERE'S AN AMERICAN HOSPITAL?

IT LOOKS LIKE YOUR TEETH ARE OK. YOU DON'T HAVE ANY WISDOM TEETH, SO THERE'S NOTHING TO PULL...

THAT'S ALL I WANTED TO HEAR...

THANKS DOC!

XIÈ XIE NǏ

IN THE PROCESS, I'D LEARNED THE CHINESE WORD FOR WISDOM TOOTH AND THE MEANING OF MESIALIZATION: THE NATURAL FORWARD MOVEMENT OF THE TEETH.

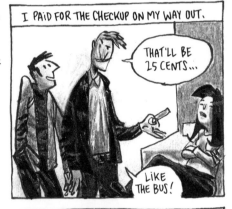

I PAID FOR THE CHECKUP ON MY WAY OUT.

THAT'LL BE 25 CENTS...

LIKE THE BUS!

LATER, I SAW WORSE AT A MARKET: A DENTIST WITH A PEDAL-OPERATED DRILL.

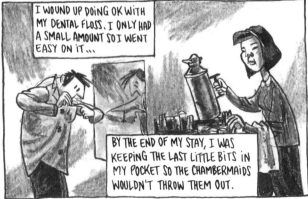

I WOUND UP DOING OK WITH MY DENTAL FLOSS. I ONLY HAD A SMALL AMOUNT SO I WENT EASY ON IT...

BY THE END OF MY STAY, I WAS KEEPING THE LAST LITTLE BITS IN MY POCKET SO THE CHAMBERMAIDS WOULDN'T THROW THEM OUT.

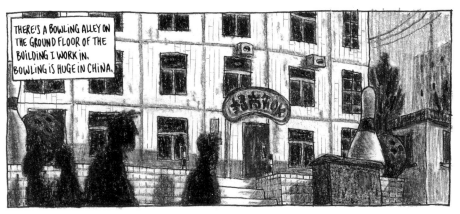

THERE'S A BOWLING ALLEY ON THE GROUND FLOOR OF THE BUILDING I WORK IN. BOWLING IS HUGE IN CHINA.

AT WORK, I TELL THE ANIMATORS HOW TO REDO CERTAIN SEQUENCES...

BLAH BLAH AND BLAH

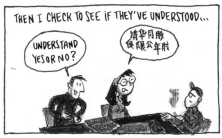

THEN I CHECK TO SEE IF THEY'VE UNDERSTOOD...

UNDERSTAND YES OR NO?

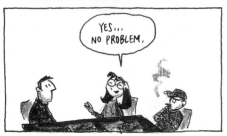

HALF THE ANIMATORS ARE ASLEEP. I DON'T UNDER-STAND HOW THEY CAN BE SINCE WE'RE USUALLY OVER-LOADED AND THE PLACE SHOULD BE RUNNING FULL TILT ...

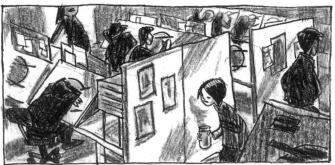

I SIT BACK AND WAIT, READING SPIROU COMICS THAT MY EMPLOYER, DUPUIS-ANIMATION, USED TO SEND TO THE FORMER DIRECTOR.

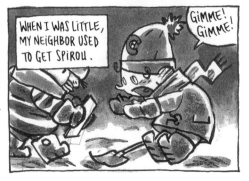

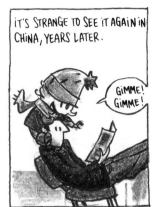

IT'S STRANGE TO SEE IT AGAIN IN CHINA, YEARS LATER.

GIMME! GIMME!

SAME OLD PICTURES, SAME LOUSY JOKES...

WHO THINKS THIS IS FUNNY?

I FEEL LIKE I'VE COME ACROSS A PAST ACQUAINTANCE WHOSE INTERESTS HAVEN'T CHANGED SINCE WE WERE KIDS.

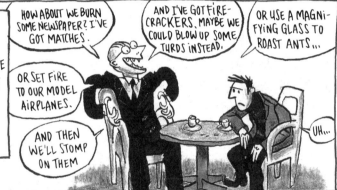

HOW ABOUT WE BURN SOME NEWSPAPER? I'VE GOT MATCHES.

AND I'VE GOT FIRE-CRACKERS, MAYBE WE COULD BLOW UP SOME TURDS INSTEAD.

OR USE A MAGNI-FYING GLASS TO ROAST ANTS...

OR SET FIRE TO OUR MODEL AIRPLANES.

AND THEN WE'LL STOMP ON THEM

UH...

ZZZ

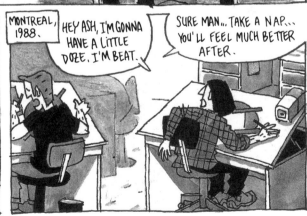

MONTREAL, 1988.

HEY ASH, I'M GONNA HAVE A LITTLE DOZE. I'M BEAT.

SURE MAN... TAKE A NAP... YOU'LL FEEL MUCH BETTER AFTER.

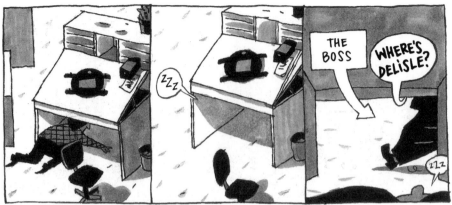

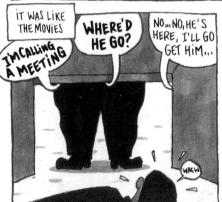

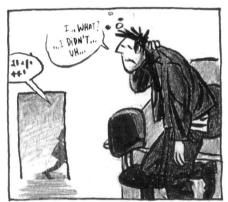

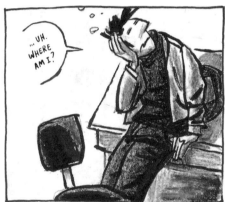

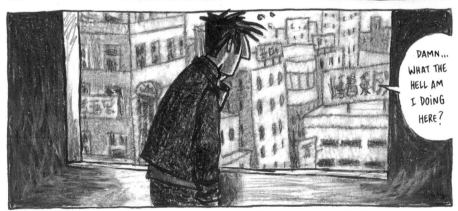

ONE DAY, I STEPPED INTO THE FIRST EATERY I CAME ACROSS. SINCE I COULD ALMOST MAKE MYSELF UNDERSTOOD, I ADOPTED IT FOR MOST OF MY STAY.

GETTING MY ORDER RIGHT INVOLVED A FEW STEPS...

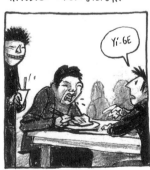

YI-GE

FIRST, I TRIED THE SAME AS THE GUY NEXT TO ME. TOO SPICY... HICCUPS.

MADE A SPECTACLE OF MYSELF FOR THE OTHER DINERS.

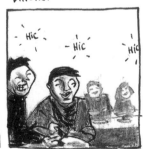

- HIC
- HIC
- HIC

MY SECOND TRY WAS BETTER.
I ASKED FOR THE NAME OF THE
DISH IN WRITING.

YUMM.

THREE TIMES A WEEK, SCRAP
OF PAPER IN HAND, I ATE THE
SAME DISH. WITHOUT HAVING
TO SAY A WORD.

HELLO!

TEA?

THANKS.

WHAT WOULD
YOU LIKE?

THE USUAL.

THE DISH WITH THE EGG?

EXACTLY.

ENJOY!

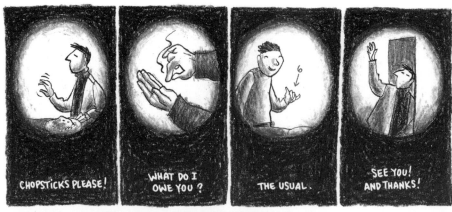

CHOPSTICKS PLEASE!

WHAT DO I OWE YOU?

THE USUAL.

SEE YOU! AND THANKS!

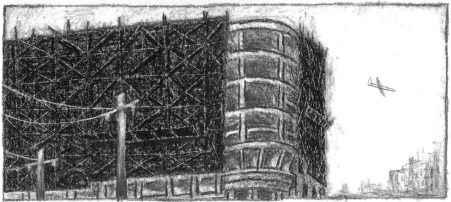

SOMETIMES I'D SEE THE COOK IN THE STREET. TO SAY HELLO, HE WOULD DO THE SIGN OF THE EGG DISH, SMILING.

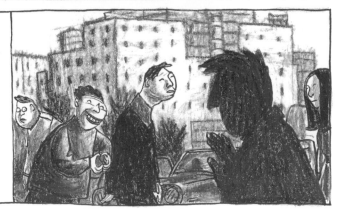

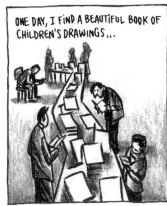

ONE DAY, I FIND A BEAUTIFUL BOOK OF CHILDREN'S DRAWINGS...

图46 爸爸的像 赵鑫 女6岁

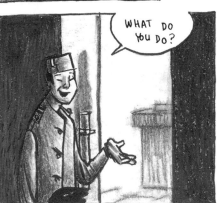

WHAT DO YOU DO?

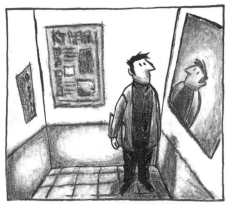

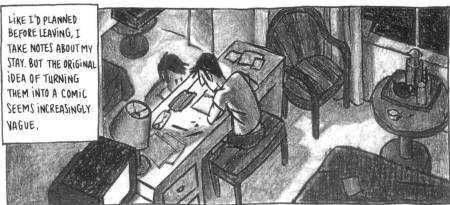

LIKE I'D PLANNED BEFORE LEAVING, I TAKE NOTES ABOUT MY STAY. BUT THE ORIGINAL IDEA OF TURNING THEM INTO A COMIC SEEMS INCREASINGLY VAGUE.

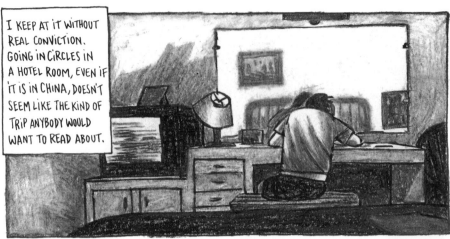

I KEEP AT IT WITHOUT REAL CONVICTION. GOING IN CIRCLES IN A HOTEL ROOM, EVEN IF IT IS IN CHINA, DOESN'T SEEM LIKE THE KIND OF TRIP ANYBODY WOULD WANT TO READ ABOUT.

BUT SINCE THERE'S NOTHING ELSE TO DO, I WRITE A PAGE EVERY EVENING.

I TRY NOT TO FEEL SORRY FOR MYSELF, EVEN AFTER I READ ABOUT JOCHEN'S TRIP TO NEW YORK.

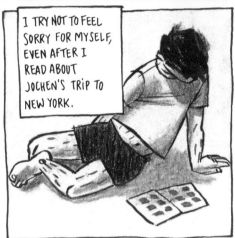

IN THE WINDOW OF "MAD COW", A COW WITH FLASHING EYES NODS ITS HEAD MECHANICALLY, FROTHING AT THE MOUTH...

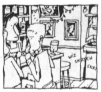

WE EAT CHICKEN WINGS, LISTENING TO A LIVE DJ AND WATCHING KUNG FU VIDEOS.

AT "MAX FISH", THE MURALS AND VIDEOS CHANGE WITH EVERY EXHIBIT...

OH MAN...

IN MY LIFE AS A DOG, YOUNG INGEMAR PLAYS DOWN HIS BAD LUCK BY THINKING ABOUT LAÏKA, THE DOG SENT ON A ONE-WAY TRIP INTO ORBIT, DOOMED TO DRIFT THROUGH SPACE.

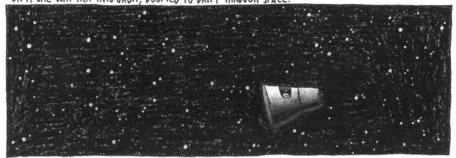

I THINK ABOUT PEOPLE WHO ARE KIDNAPPED AND HELD CAPTIVE FOR NO REASON, NOT KNOWING WHEN THEY'LL BE RELEASED.

BEFORE LEAVING, I HAD READ AN ACCOUNT BY CHRISTOPHE ANDRÉ, WHO MANAGED TO ESCAPE TO AN EMBASSY AFTER BEING HELD HOSTAGE IN CHECHNYA FOR 111 DAYS. HE SPOKE OF THE SATISFACTION OF HAVING REGAINED HIS FREEDOM ALONE, INSTEAD OF BEING TRADED LIKE A COMMODITY. SURELY THE BEST WAY OUT, PSYCHOLOGICALLY.

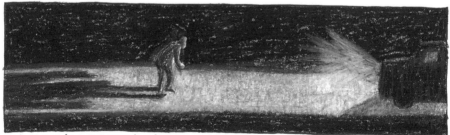

IS IT BEING IN A COUNTRY LIKE CHINA THAT'S GOT ME THINKING ABOUT FREEDOM?

MORNINGS, WHEN THE FLOOR CLERK SEES ME LEAVE THE ROOM, SHE RUNS AHEAD TO CALL THE ELEVATOR. YOU'VE ONLY GOT TO PRESS THE BUTTON ONCE.

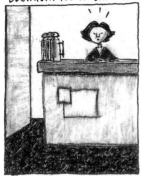

BUT SHE KEEPS PRESSING UNTIL THE ELEVATOR ARRIVES. SHE MUST THINK PURE DETERMINATION WILL MAKE IT COME FASTER.

 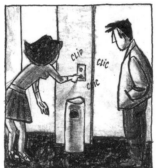 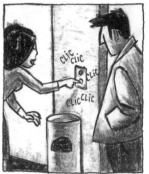

I'D EXPLAIN MY POINT OF VIEW, BUT I DON'T SEE HOW WITH HAND SIGNALS. SO I STAND BACK AND WATCH.

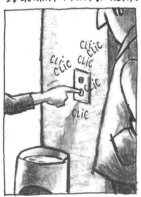 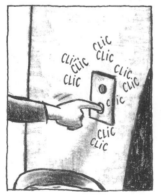

36

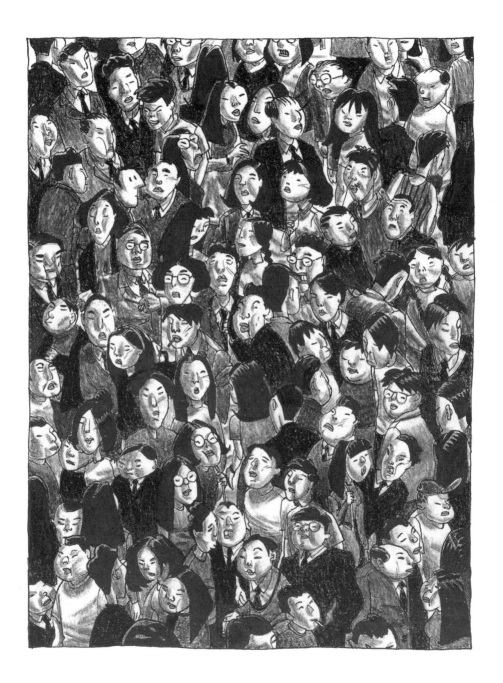

THE DESCENT TO HELL, ACCORDING TO DANTE:

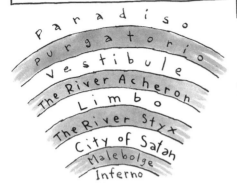

Paradiso
purgatorio
Vestibule
The River Acheron
Limbo
The River Styx
City of Satan
Malebolge
Inferno

SAME THING, TRANSPOSED TO CHINA:

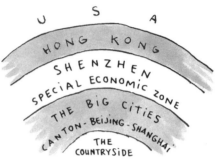

U S A
HONG KONG
SHENZHEN
SPECIAL ECONOMIC ZONE
THE BIG CITIES
CANTON - BEIJING - SHANGHAI
THE COUNTRYSIDE

UNLESS YOU'RE AN ILLEGAL OR GETTING PAID UNDER THE TABLE, EACH STEP REQUIRES A VISA THAT'S HARD TO GET, SEEING THAT JUST ABOUT EVERYONE WANTS OUT.

TO THE NORTH FOR EXAMPLE, SHENZHEN IS SEALED OFF BY AN ELECTRIC FENCE GUARDED DAY AND NIGHT BY SOLDIERS IN WATCHTOWERS... I COULD SEE THEM CLEARLY FROM MY WINDOW.

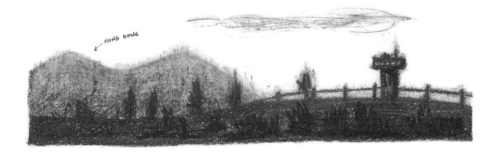

← HONG KONG

MY FIRST TIME THROUGH THE
ELECTRIC ZONE CAME THANKS
TO AN INVITATION FROM A
STUDIO IN CANTON. A KIND
OF BUSINESS TRIP TO SEE
A NEW STUDIO STAFFED
MOSTLY BY THE BEST OF
OUR OWN FORMER
ANIMATORS.

SATURDAY MORNING: RENDEZVOUS
AT A CHIC HOTEL.

AND THEN 2 HOURS ON THE
ROAD, HEADING NORTH.

IN THE MIDDLE OF NOWHERE, HUGE CONSTRUCTION SITES RISE OUT OF THE GROUND... GIGANTIC
BUILDINGS LIKE CONVENTION CENTERS, BUT WITHOUT A SURROUNDING CITY.

CONSTRUCTION... EMPTY
LOTS... CONSTRUCTION...
IT GOES ON FOR HOURS.
NOT MUCH MORE DE-
PRESSING THAN THE STRETCH
OF HIGHWAY BETWEEN
MONTREAL AND QUEBEC
CITY.

EXCEPT BACK HOME, IT'S TREES ... EMPTY LOTS... TREES...

CROSSING A VIADUCT, I SEE A MAN SQUATTING IN THAT TYPICAL ASIAN WAY, QUIETLY READING HIS NEWSPAPER WHILE BALANCING ON THE RAILING...

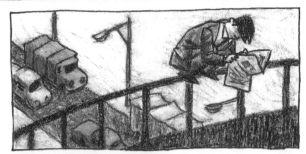

CANTON ...

FINALLY, THE KIND OF CITY YOU SEE IN DOCUMENTARIES.

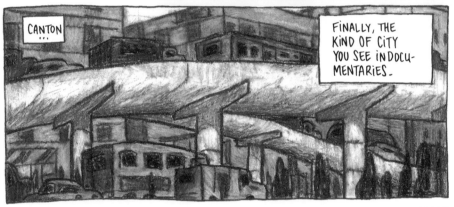

FROM THE MOMENT I ARRIVE, I'M TAKEN CARE OF. A TRANSLATOR JOINS US AND INTRODUCES ME TO A LOT OF PEOPLE.

AT THE HOLIDAY INN RESTAURANT, I EAT A DELICIOUS SNAKE SOUP...

THE WAITER POURS FRUIT TEA FROM AN ODD-LOOKING TEAPOT.

THE HOTEL MANAGER WELCOMES US BY PRESENTING HIS BUSINESS CARD.

IN CHINA, CARDS ARE OFFERED WITH BOTH HANDS...

AND RECEIVED THE SAME WAY

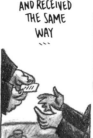

THEN, YOU'RE EXPECTED TO SEEM INTERESTED...

HMMM...FASCINATING.

THAT DAY, I TOUR THE STUDIO (MUCH NICER THAN THE ONE IN SHENZHEN), AM BROUGHT BACK TO THE HOTEL AND WANDER AROUND.

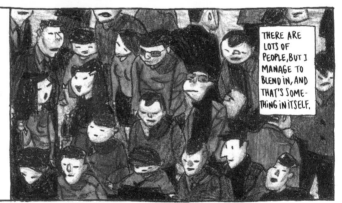

THERE ARE LOTS OF PEOPLE, BUT I MANAGE TO BLEND IN, AND THAT'S SOMETHING IN ITSELF.

THERE'S A LOT TO SEE IN CANTON: OLD MARKETS, PAGODAS, MUSEUMS...

BUT ABOVE ALL, OH JOY... THERE ARE CAFÉS THAT SERVE REAL COFFEE!

HERE, FOR AN EXOTIC TOUCH, IS A LOOK AT HOW OUR CHINESE FRIENDS MAKE POPCORN.

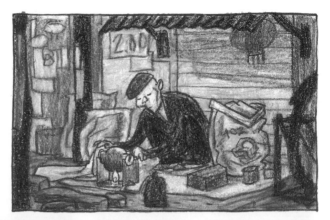

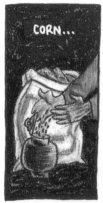

CORN...

HEAT...

OPEN UP...

BOOM

AND ENJOY! YUM.

NEXT DAY, I VISIT A TELEVISION STATION, JOINED BY THE BOSS AND A FEW MANAGERS. AT SOME POINT, TALK TURNS TO SALARIES... I EXPLAIN THAT BACK HOME, TECHNICIANS LIKE THOSE WE JUST MET ARE PAID OVERTIME ON SUNDAYS.

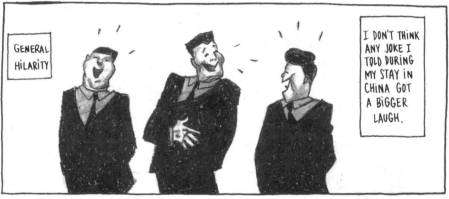

GENERAL HILARITY

I DON'T THINK ANY JOKE I TOLD DURING MY STAY IN CHINA GOT A BIGGER LAUGH.

AFTERWARD, IT'S A TOUR OF THE CITY WITH THE TRANSLATOR AND CHAUFFEUR.

HURRAY!

MY TRANSLATOR MUST HAVE BEEN TOLD TO STICK WITH ME. HE EVEN TAGS ALONG TO THE SHITTER.

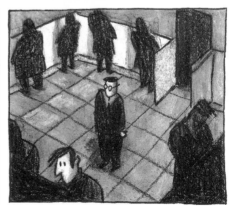

AFTER A WHILE, HE PRETENDS TO TAKE A LEAK...

OUR DRIVER (I WASN'T TOLD HIS NAME) HAS A FACE MADE FOR THE MOVIES. AN ASIAN BOGART.

AT THE MUSEUM, IT SOUNDS LIKE HE KNOWS VOLUMES ABOUT MING VASES.

BUT MY TRANSLATOR, IN A SHOW OF PASSIVE RESISTANCE, TRANSLATES ONLY A FRACTION OF WHAT HE SAYS.

未經許可,禁止在景區
判參自行撕下無效。
身高 1.1 米以下的兒
1.4 米的兒童須購
的游客須購全票。

米

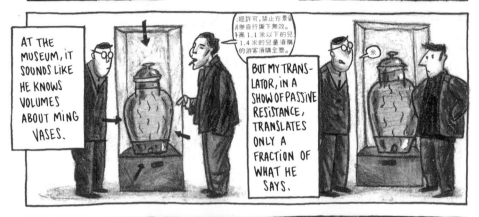

THAT EVENING, WE END UP IN A PSEUDO-KOREAN RESTAURANT ...

I HAVE NEVER SEEN ANYONE, ANYWHERE, PUT AS MUCH SALT ON FOOD.

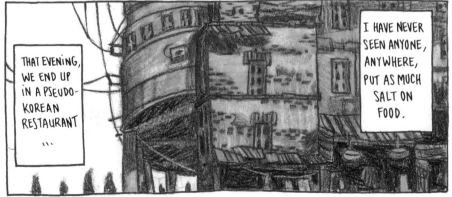

FASCINATED, I WATCH THE CHEF FRY
UP RICE, CANTONESE STYLE, WITH
SHRIMP, EGGS, SOY SAUCE, A BIT OF PEPPER

A BIT OF SALT

A BIT MORE...

IT'S UNREAL. SHE DOESN'T STOP.

IS SHE JOKING?

WHO'S GOING TO EAT THAT?

LATER, AFTER RACING AGAINST THE CLOCK THROUGH CANTONESE TRAFFIC, I MANAGE TO MAKE IT
ONTO THE SHENZHEN EXPRESS, THANKS TO OLD BOGIE, THE DRIVER.

45

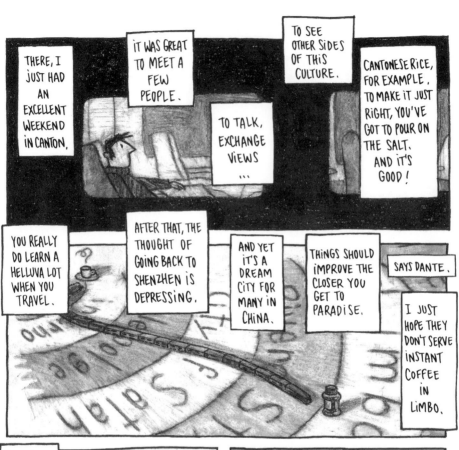

THERE, I JUST HAD AN EXCELLENT WEEKEND IN CANTON.

IT WAS GREAT TO MEET A FEW PEOPLE.

TO SEE OTHER SIDES OF THIS CULTURE.

TO TALK, EXCHANGE VIEWS ...

CANTONESE RICE, FOR EXAMPLE, TO MAKE IT JUST RIGHT, YOU'VE GOT TO POUR ON THE SALT. AND IT'S GOOD!

YOU REALLY DO LEARN A HELLUVA LOT WHEN YOU TRAVEL.

AFTER THAT, THE THOUGHT OF GOING BACK TO SHENZHEN IS DEPRESSING.

AND YET IT'S A DREAM CITY FOR MANY IN CHINA.

THINGS SHOULD IMPROVE THE CLOSER YOU GET TO PARADISE.

SAYS DANTE.

I JUST HOPE THEY DON'T SERVE INSTANT COFFEE IN LIMBO.

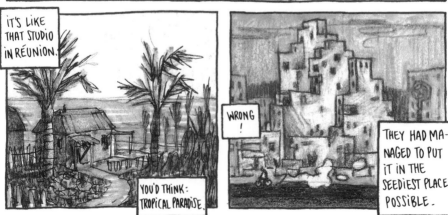

IT'S LIKE THAT STUDIO IN RÉUNION.

YOU'D THINK: TROPICAL PARADISE.

WRONG!

THEY HAD MANAGED TO PUT IT IN THE SEEDIEST PLACE POSSIBLE.

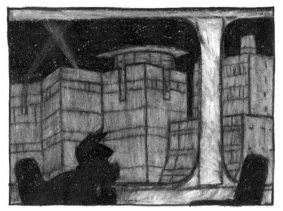

A YOUNG MAN COMES UP AND WE TRY TO CONVERSE.

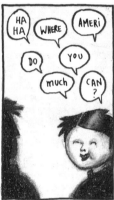

HA HA WHERE AMERI DO YOU much CAN ?

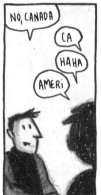

NO, CANADA CA HA HA AMERI

ME WOLK OF COURSE MARKET STOCK COPPER YES

YOU FROM WHERE BUSINESS EXCHANGE YES AMERI CAN ?

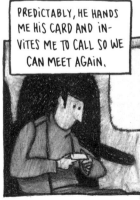

PREDICTABLY, HE HANDS ME HIS CARD AND IN-VITES ME TO CALL SO WE CAN MEET AGAIN.

YOU NO CARD?

FACING THE DOOR, THE HOSTESS GIVES A MILITARY SALUTE AS WE PULL INTO THE STATION.

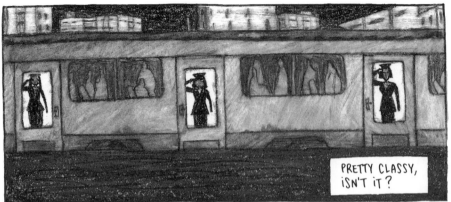

PRETTY CLASSY, ISN'T IT?

BACK AT THE GREAT WALL HOTEL.

WHAT TIME IS IT?

HE'S STARTING TO GET ON MY NERVES.

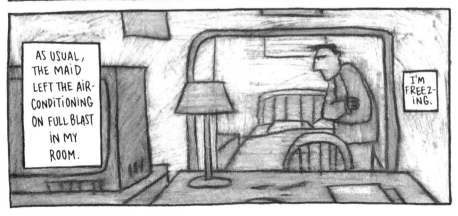

AS USUAL, THE MAID LEFT THE AIR-CONDITIONING ON FULL BLAST IN MY ROOM.

I'M FREEZ-ING.

FEELING A BIT FED UP, I GIVE THE THERMOSTAT A LITTLE KICK.

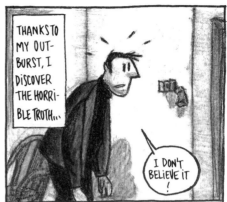

THANKS TO MY OUTBURST, I DISCOVER THE HORRIBLE TRUTH...

I DON'T BELIEVE IT !

A CAMERA!

I'VE BEEN UNDER SURVEILLANCE ALL ALONG!...

MUST BE THE KGB!

NO, NOT AT ALL.

THERE IS NO CAMERA... AND BESIDES, THE KGB IS SOVIET, NOT CHINESE.

BUT I DISCOVER SOMETHING ELSE : THE TEMPERATURE CONTROL ON THE AC DOESN'T CONTROL A THING. IT'S JUST A PLASTIC DIAL HELD IN PLACE BY A SCREW.

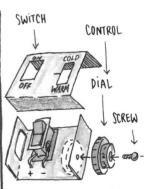

SWITCH

CONTROL

DIAL

SCREW

COLD AND WARM, MY ASS.

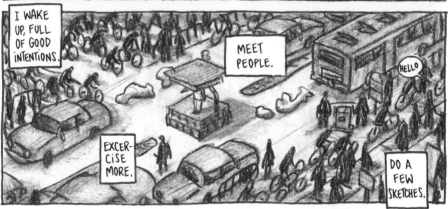

I WAKE UP, FULL OF GOOD INTENTIONS.

EXCER-CISE MORE.

MEET PEOPLE.

HELLO

DO A FEW SKETCHES.

AT THE CORNER, A GROUP OF WOMEN REPAIR THE STREET WITH PICKS AND SHOVELS.

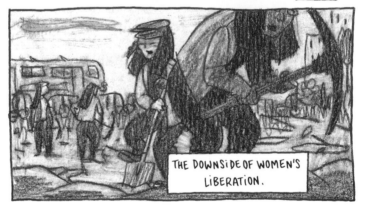

THE DOWNSIDE OF WOMEN'S LIBERATION.

DECEMBER 1.
I SEE A MOUSE IN THE STUDIO.

THIS MORNING, THERE'S A STACK OF WORK.

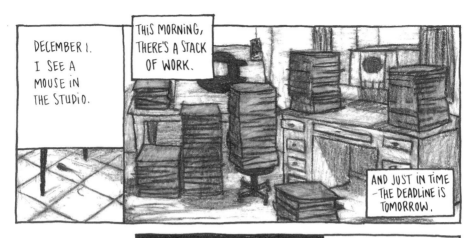

AND JUST IN TIME —THE DEADLINE IS TOMORROW.

IT'S THE GOOD OLD CHINESE METHOD: LET THINGS PILE UP TILL THE LAST MINUTE SO THE EPISODE IS CHECKED AND APPROVED IN A RUSH.

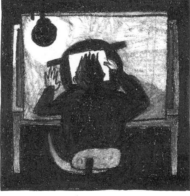

BUT SINCE I DON'T PARTICULARLY WANT TO WORK THEIR WAY, I WALK OUT HALFWAY THROUGH THE EVENING.

BEFORE LEAVING, I DISCOVER WHY PEOPLE AT THE STUDIO USE ONLY THE URINAL TO THE RIGHT.

SHiiiiiiT.

THAT EVENING, I MEET UP WITH CHEUN, MY FRIEND FROM THE TRAIN, AND WE GO EAT DOG AT A RESTAURANT I HAD FOUND.

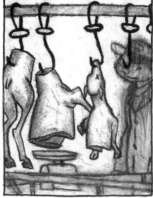

I'M THRILLED TO HAVE A GUIDE AND HE'S HAPPY TO PRACTICE HIS ENGLISH.

WE DIP VEGETABLES INTO A BROTH BRIMMING WITH PIECES OF MEAT AND EAT THEM WITH MUSHROOM SAUCE.

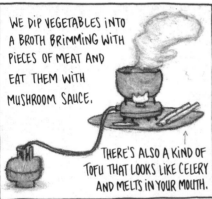

THERE'S ALSO A KIND OF TOFU THAT LOOKS LIKE CELERY AND MELTS IN YOUR MOUTH.

DOG ISN'T BAD. IT TASTES GAMEY, A BIT LIKE MUTTON.

SUDDENLY, THE TABLE NEXT TO US CATCHES FIRE.

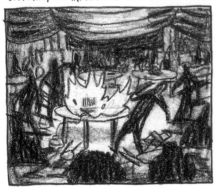

THE FLAME CRAWLS DANGEROUSLY DOWN THE RUBBER HOSE.

LUCKILY, A HEROIC WAITER TURNS OFF THE GAS IN TIME. WE DRINK TO OUR BRUSH WITH DEATH.

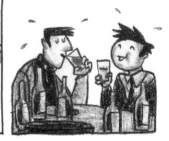

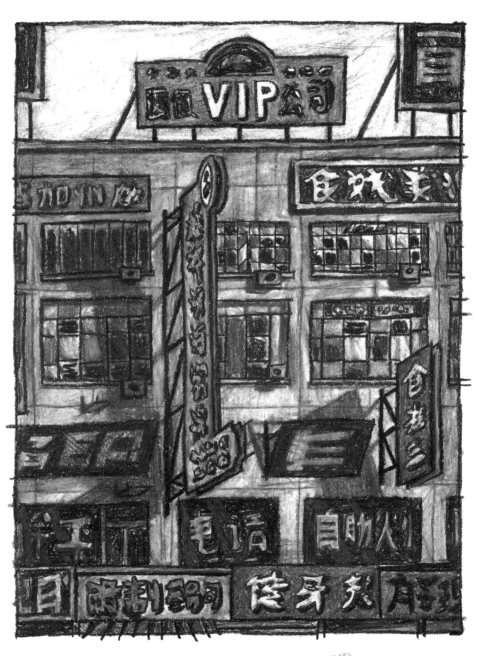

I PASS BY MANY ODD SHOPS ON MY WAY TO WORK.

THERE ARE A FEW THAT SELL SAFES AND INSTANT SOUPS.

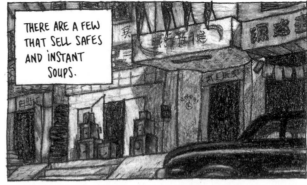

WHICH SAYS A LOT ABOUT THE CONCERNS OF THE AVERAGE CUSTOMER.

A SAFE AND TWO SOUPS, PLEASE.

THEY'RE ALL GREEN WITH LITTLE DECORATIONS IN THE CORNERS, LUCKY LUKE STYLE.

CHINA, THE FAR WEST

THERE'S ALSO A SURREAL FASHION ALLEY.

THE VENDORS DISPLAY THEIR COLLECTIONS ON THE SAME TWO MANNEQUINS, ALL PLACED THE SAME WAY ON EITHER SIDE OF THEIR SHOPS. A KIND OF MILITARY FASHION PARADE, BUT STATIONARY.

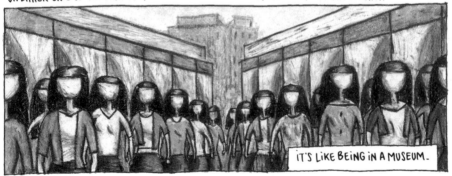

IT'S LIKE BEING IN A MUSEUM.

TO SPEED THINGS UP, I SPEND EVERY MORNING REDOING THE WORST OF THE SCENES.

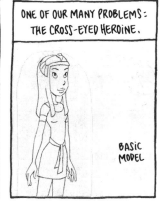

ONE OF OUR MANY PROBLEMS: THE CROSS-EYED HEROINE.

BASIC MODEL

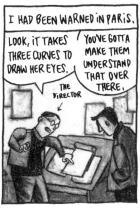

I HAD BEEN WARNED IN PARIS.

LOOK, IT TAKES THREE CURVES TO DRAW HER EYES.

YOU'VE GOTTA MAKE THEM UNDERSTAND THAT OVER THERE.

THE DIRECTOR

HMM... HMM...

I CAN'T WAIT.

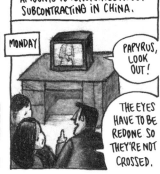

IT'S A KIND OF CONCERN THAT AMOUNTS TO IGNORANCE ABOUT SUBCONTRACTING IN CHINA.

MONDAY

PAPYRUS, LOOK OUT!

THE EYES HAVE TO BE REDONE SO THEY'RE NOT CROSSED.

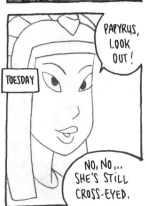

PAPYRUS, LOOK OUT!

TUESDAY

NO, NO... SHE'S STILL CROSS-EYED.

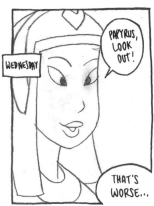

PAPYRUS, LOOK OUT!

WEDNESDAY

THAT'S WORSE...

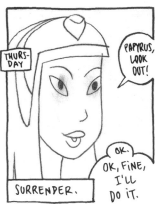

PAPYRUS, LOOK OUT!

THURSDAY

SURRENDER.

OK. OK, FINE, I'LL DO IT.

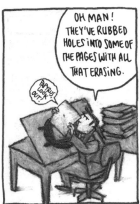

OH MAN! THEY'VE RUBBED HOLES INTO SOME OF THE PAGES WITH ALL THAT ERASING.

PAPYRUS, LOOK OUT!

YOU'D THINK THEY WOULDN'T HAVE A PROBLEM DRAWING ALMOND-SHAPED EYES.

ESPECIALLY ONE OF THEM, A VERY TALL MANCHURIAN WITH VERY SLANTED EYES.

HA HA HA

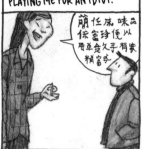

BUT EITHER HE FOUND THE WHOLE THING HILARIOUS OR HE WAS PLAYING ME FOR AN IDIOT.

萠任成味品佈富玲便以晉卑盒久手有裳精富哭

HA HA HA HA HA HA HA HA HA

王佃业秾淉 行俱程自电金印助火滔祜水圍三

I DIDN'T CATCH THAT...

UH... HE SAYS HE WILL DO THE EYES BETTER NEXT TIME.

HMM.

CAN'T LET MYSELF GET TOO PARA-NOID IN THIS KIND OF CONTEXT.

BASICALLY, EVERYTHING DEPENDS ON THE STORYBOARD.

WHEN IT'S A MESS, ANYTHING CAN HAPPEN.

THE BETTER IT'S DRAWN, THE BETTER THE EPISODE...

TO CUT AN ADDITIONAL JOB, THE PRODUCTION TEAM ASSIGNED LAYOUT TO THE CHINESE.

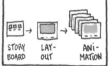

STORY BOARD → LAY-OUT → ANI-MATION

RESULT:

THERE IS NO LAYOUT TEAM. INSTEAD, ANIMATORS WORK FROM PHOTOCOPY ENLARGEMENTS OF STORYBOARD PANELS.

WHICH IS HIGHLY UNORTHODOX IN TERMS OF PRODUCTIVITY.

WHEN I CAME TO MONTPELLIER IN 1990, 3 STUDIOS THERE EMPLOYED ANIMATORS.

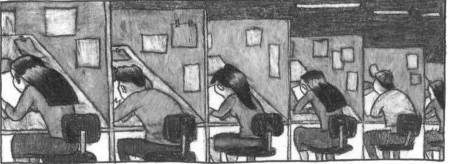

TEN YEARS LATER, ANIMATORS ARE VIRTUALLY OBSOLETE, AND LAYOUT HAS MET THE SAME FATE.

IT'S TOO BAD. ANIMATION USED TO BE
A NICE PROFESSION.

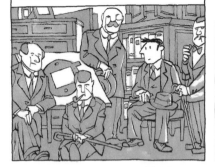

BECAUSE IF YOU CAN MASTER THE BASICS OF MOVEMENT,
YOUR OBSERVATIONAL SKILLS IMPROVE DRAMATICALLY
THANKS TO YOUR BIONIC EYE.

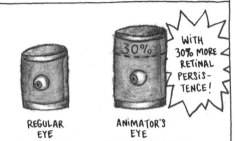

REGULAR
EYE

ANIMATOR'S
EYE

WITH
30% MORE
RETINAL
PERSIS-
TENCE!

TAKE AN ANIMATOR
IN A PARK...

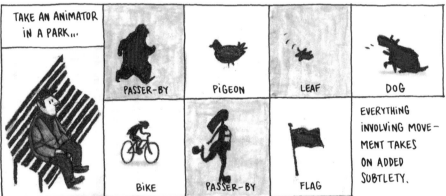

PASSER-BY

PIGEON

LEAF

DOG

BIKE

PASSER-BY

FLAG

EVERYTHING
INVOLVING MOVE-
MENT TAKES
ON ADDED
SUBTLETY.

WITH PRACTICE, AN ANIMATOR CAN EVEN MAKE TIME STAND STILL FOR A MOMENT.

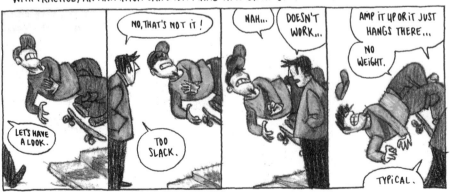

LET'S HAVE
A LOOK.

NO, THAT'S NOT IT!

TOO
SLACK.

NAH...

DOESN'T
WORK...

AMP IT UP OR IT JUST
HANGS THERE...

NO
WEIGHT.

TYPICAL.

WITH SUB-CONTRACTING, ANIMATION QUALITY HAS TAKEN A HIT.

BUT SINCE THIS IS A TV SERIES, "IT'LL DO", AS THEY SAY.

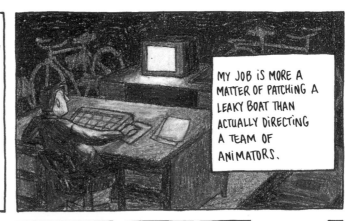

MY JOB IS MORE A MATTER OF PATCHING A LEAKY BOAT THAN ACTUALLY DIRECTING A TEAM OF ANIMATORS.

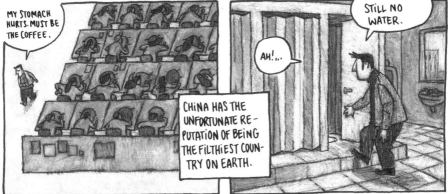

MY STOMACH HURTS. MUST BE THE COFFEE.

AH!...

STILL NO WATER.

CHINA HAS THE UNFORTUNATE RE-PUTATION OF BEING THE FILTHIEST COUN-TRY ON EARTH.

SPECTACULAR, BUT YOU GET USED TO IT... IT BECOMES NORMAL ... EVEN THE SMELL THAT'S SO REPULSIVE AT FIRST TAKES ON SUBTLETIES THAT YOU COME TO APPRECIATE.

HMM...

... VERY COLORFUL TODAY.

BACK AT THE HOTEL, THE DAY'S EVENTS INSPIRE A FEW THOUGHTS THAT I JOT DOWN BEFORE GOING TO BED.

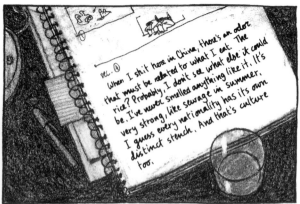

DEC. 8

When I shit here in China, there's an odor that must be related to what I eat. The rice? Probably, I don't see what else it could be. I've never smelled anything like it. It's very strong, like sewage in summer, I guess every nationality has its own distinct stench. And that's culture too.

HELLO!

THIS SATURDAY MORNING, I HAVE A SUDDEN URGE TO GET ON MY BIKE, MAKE MY WAY THROUGH THE CITY AND EXPLORE CHINA'S COUNTRYSIDE... BASICALLY, THERE'S NOTHING ELSE TO DO.

AFTER A GOOD TWO HOURS OF HARD WORK, I'M BLOCKED BY A RAMP THAT MERGES WITH A HIGHWAY. I TURN AROUND.

GREAT WEEKEND.

HELLO!

NEXT DAY, I VISIT THE CITY'S ONLY TOURIST ATTRACTION WITH CHEUN,

"WINDOWS OF THE WORLD", A THEME PARK OFFERING LOCALS A CONDENSED TOUR OF THE WORLD.

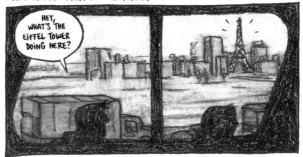

HEY, WHAT'S THE EIFFEL TOWER DOING HERE?

IT'S GOT ALL THE GREAT MONUMENTS.

BUT 19 TIMES SMALLER.

EXCEPT THE EIFFEL TOWER.

ONE THIRD

JONATHAN SWIFT WOULD HAVE LIKED THIS.

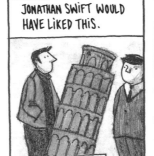

ITALY

THE PONT DU GARD.

FRANCE

THE GREAT PYRAMIDS.

EGYPT

THE GRAND CANYON (PLASTIC).

USA

IN AUSTRALIA, A GUY ASKS ME TO POSE FOR A PICTURE WITH HIS WIFE.

NO PROBLEM.

MY COMPANION SEEMS VERY PROUD OF THE SITUATION...

HER HUSBAND TELLS EVERYONE THAT I'M FRENCH.

THERE'S A DWÉLÉ DANCE PERFORMANCE IN THE AFRICA SECTION. I HURRY OVER. AFRICANS ARE RARE IN CHINA.

TURNS OUT THEY'RE CHINESE FROM THE NORTHWEST (LESS TYPICALLY ASIAN), COVERED IN SHOE POLISH AND GOOFING AROUND LIKE KIDS.

WOW...

THAT WAS WORTH THE TRIP...

DEFINITELY THE HIGHLIGHT OF THE DAY!

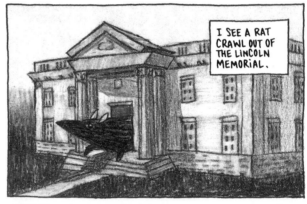

I SEE A RAT CRAWL OUT OF THE LINCOLN MEMORIAL.

AS WE NEAR THE CERAMIC REPLICA OF SOUTH SIDE MANHATTAN, MY GUIDE LIVENS UP...

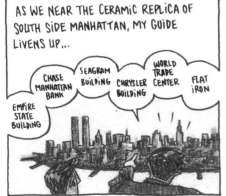

EMPIRE STATE BUILDING

CHASE MANHATTAN BANK

SEAGRAM BUILDING

CHRYSLER BUILDING

WORLD TRADE CENTER

FLAT IRON

I TELL HIM ABOUT MY RECENT STAY THERE. WHEN I DESCRIBE CHINATOWN, HE'S RIVETED, GASPING IN AMAZEMENT.

NEXT DOOR IS ANOTHER THEME PARK, "SPLENDID CHINA", DEDICATED TO THE COUNTRY'S OWN MARVELS.

CHEUN HAS NEVER SET FOOT THERE, EVEN THOUGH THIS IS HIS 5TH TIME AT "WINDOWS OF THE WORLD".

WILL YOU GO VISIT "SPLENDID CHINA" ONE DAY?

NO.

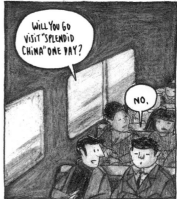

IT DOES LEAVE YOU WITH AN URGE TO TRAVEL...

I WOULDN'T MIND SEEING THE TAJ MAHAL ONE OF THESE DAYS...

WHEN I THINK THAT ALL I'VE GOT TO DO IS BUY A TICKET...

I CAN GO WHERE I LIKE...

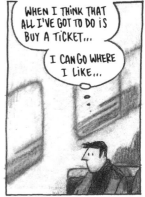

WE HARDLY EVER STOP TO NOTICE HOW AMAZINGLY FREE WE REALLY ARE.

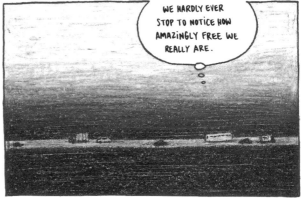

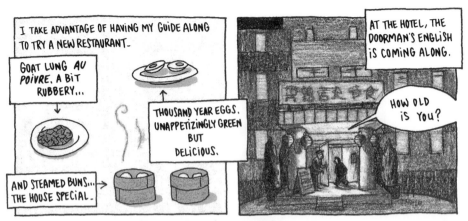

I TAKE ADVANTAGE OF HAVING MY GUIDE ALONG TO TRY A NEW RESTAURANT.

GOAT LUNG *AU POIVRE*, A BIT RUBBERY...

THOUSAND YEAR EGGS, UNAPPETIZINGLY GREEN BUT DELICIOUS.

AND STEAMED BUNS... THE HOUSE SPECIAL.

AT THE HOTEL, THE DOORMAN'S ENGLISH IS COMING ALONG.

HOW OLD IS YOU?

SHENZHEN IS THE FASTEST GROWING CITY IN THE WORLD.

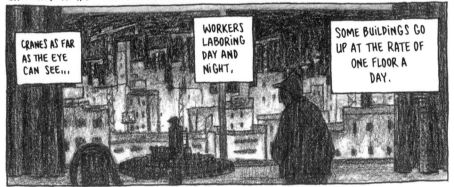

CRANES AS FAR AS THE EYE CAN SEE...

WORKERS LABORING DAY AND NIGHT,

SOME BUILDINGS GO UP AT THE RATE OF ONE FLOOR A DAY.

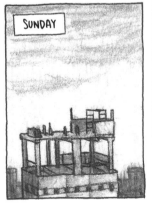

SUNDAY

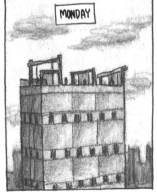

MONDAY

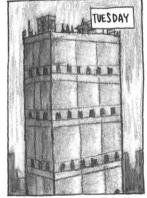

TUESDAY

A DETAIL IN THE STREET REMINDS ME THAT CHRISTMAS ISN'T FAR OFF...

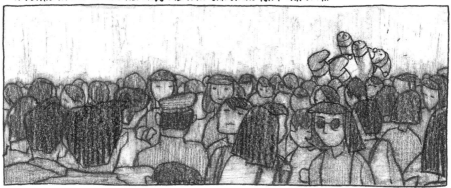

THAT DAY, GOING BY THE MARKET, I SAW ONE OF THE MOST INCREDIBLE SIGHTS OF MY TRIP...

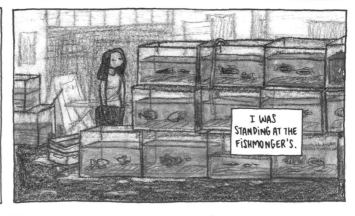

I WAS STANDING AT THE FISHMONGER'S.

IN CHINA, WHEN A FISH ISN'T FRESH, IT'S FLOATING BELLY UP.

MMM... NICE AMBIANCE.

AT THE MARKETS, GARBAGE IS THROWN INTO THE CENTER OF THE AISLES. IN THE COURSE OF THE DAY, PASSERSBY GRIND IT DOWN UNDERFOOT UNTIL IT GRADUALLY TURNS TO MUSH.

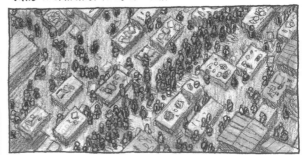

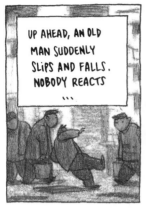

UP AHEAD, AN OLD MAN SUDDENLY SLIPS AND FALLS. NOBODY REACTS ...

HE GETS UP AND WHEN I'M NEXT TO HIM, I NOTICE A BANANA PEEL AT HIS FEET...

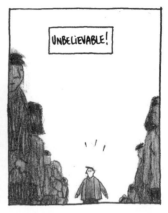

UNBELIEVABLE!

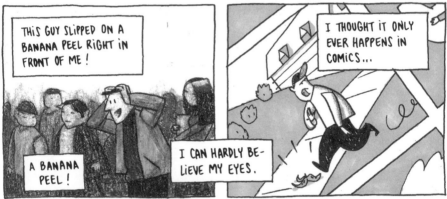

THIS GUY SLIPPED ON A BANANA PEEL RIGHT IN FRONT OF ME!

A BANANA PEEL!

I CAN HARDLY BE-LIEVE MY EYES.

I THOUGHT IT ONLY EVER HAPPENS IN COMICS...

IS THAT WHAT I CAME ALL THIS WAY FOR?

MY TRIP BEGINS TO SEEM MEANINGFUL.

THE STUDIO IS ON THE 8TH FLOOR. THERE ARE TWO ELEVATORS, ONE OF WHICH IS ALWAYS BROKEN, SO IT OFTEN TAKES FOREVER...

BEFORE LONG, THERE'S A CROWD. I KNOW MOST OF THE PEOPLE AND WORK WITH THEM EVERY DAY, BUT WITHOUT A TRANSLATOR, WE CAN'T COMMUNICATE.

OR ELSE I TAKE THE STAIRS.

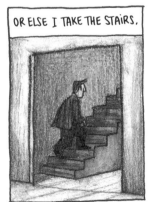

ON THE 5TH FLOOR, THERE'S AN EMPTY SAFE...

ON THE 7TH, A COUPLE LIVING IN A CLOSET-SIZED APARTMENT HANGS OUT MEAT TO DRY.

67

WE SHOULD BE WRAPPING UP AN EPISODE TODAY. THE FOLDERS ARE GETTING TATTERED.

START OF EPISODE

YESSIR, THIS ONE'LL BE GREAT

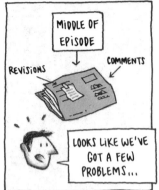

MIDDLE OF EPISODE

REVISIONS

COMMENTS

LOOKS LIKE WE'VE GOT A FEW PROBLEMS...

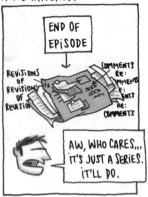

END OF EPISODE

REVISIONS OF REVISIONS OF REVISION

COMMENTS RE: COMMENTS RE: EDITS RE: COMMENTS

AW, WHO CARES... IT'S JUST A SERIES. IT'LL DO.

THINGS ARE UNUSUALLY CALM. I FIND AN OLD COPY OF *THÉODORE POUSSIN*,* IN WHICH A MYSTERIOUS CHARACTER RECITES A HAUNTING POEM BY BAUDELAIRE...

* COMIC BY FRANK LE GALL

BITTER THE KNOWLEDGE WE GET FROM TRAVELING! THE WORLD, MONOTONOUS AND MEAN TODAY, YESTERDAY, TOMORROW, ALWAYS, LETS US SEE OUR OWN IMAGE AN OASIS OF HORROR IN A DESERT OF BOREDOM.

WHEW!

THAT'S CHEERY...

THE PROJECT DIRECTOR I'VE BE-FRIENDED TELLS ME HE'S GOING IN FOR LUNG SURGERY...

HE HAS BEEN LOOKING UNDER THE WEATHER, POOR GUY...

IN THE TWO WEEKS THAT HE'S GONE, NOBODY SEEMS TO WORRY ABOUT HIM...

DO YOU HAVE ANY NEWS?

DID YOU PHONE HIM?

NO I DON'T KNOW

ONE DAY HE'S BACK, LOOKING DRAINED, WITH LONG SCARS ON HIS NECK.

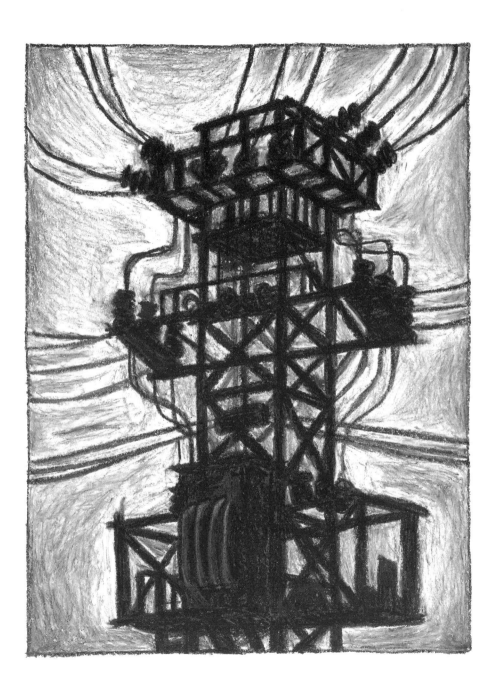

I WAS EXPLAINING TO AN ANIMATOR THAT IT'S PHYSICALLY IMPOSSIBLE TO GET UP FROM A CHAIR THE WAY HE DREW IT.

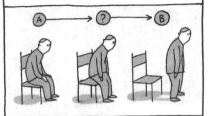

YOU HAVE TO LEAN FORWARD AND SHIFT YOUR CENTER OF GRAVITY TO STAND UP NORMALLY.

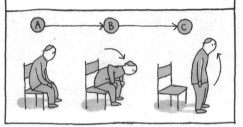

I ENCOURAGED HIM TO GIVE IT A TRY...

HE DID AND...

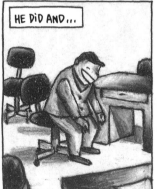

BANG!

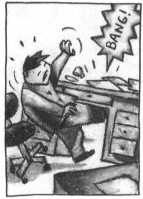

LATER, I REALIZED THAT HE'D KNOCKED OVER MY COFFEE...

HIS FOLDER WAS WORSE FOR THE WEAR.

I WIPED UP. THERE WAS STILL SOME UNDER THE GLASS, SO I SLID IN BLOTTING PAPER, THEN FORGOT ALL ABOUT IT.

INEVITABLY, MOLD DEVELOPED. I DIDN'T INTERFERE. DAY AFTER DAY, I ADMIRED THE CHANGING PATTERNS.

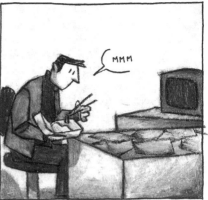

MMM

LUNCHTIME, I WAS EATING LACQUERED DUCK WHEN A GIRL FROM ANIMATION RAN IN, HANDED ME A GIFT AND DISAPPEARED.

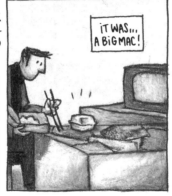

IT WAS... A BIG MAC!

SHE REPEATED THE MANEUVER A SECOND TIME, PROBABLY HOPING FOR FEWER REVISIONS.

WHEN SHE SAW THAT SHE WASN'T GETTING ANYWHERE WITH BIG MACS, SHE TRIED PHOTO ALBUMS INSTEAD.

GIRL AND TREE
GIRL AND FOUNTAIN
GIRL AND TEMPLE
GIRL AND RESTAURANT
GIRL AND PALACE
GIRL AND CAR
GIRL AND MOUNTAIN
GIRL AND POOL

...

(pff!...)

ALWAYS HER FACE AGAINST A VARIETY OF BLURRY BACKDROPS.

BUT NOTHING REALLY SEXY, UN-FORTUNATELY ...

THERE WAS ALSO AN ALBUM WITH MORE CANDID PHOTOS...

CLEARLY, MODESTY WASN'T HER PROBLEM... I LEFT THE ALBUMS WHERE I FOUND THEM AND NEVER HEARD ABOUT THEM AGAIN.

I HAD BEEN COM-MUTING TO WORK BY BIKE FOR A WHILE,

ARISE YE WORKERS

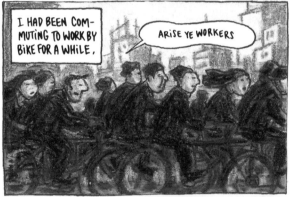

CYCLING, EVEN SLOWLY, IS A REAL CHALLENGE.

TO MANAGE, YOU FIRST HAVE TO PUT ASIDE ALL CULTU-RALLY INGRAINED POLITENESS.

A FEW BASIC PRINCIPLES APPLY...

FIRST PRINCIPLE: AN EMPTY SPACE MAY BE FILLED

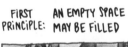

AT ANY TIME.

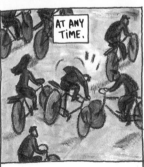

WHICH MEANS PEOPLE CAN CUT IN WHENEVER THEY LIKE,

SECOND PRINCIPLE: NOBODY ELSE MATTERS...

ESPECIALLY OUTSIDE A 5-FOOT RADIUS.

TRYING TO THINK FURTHER AHEAD IS USELESS.

WHERE'S HE GOING?

TO THE LEFT.

RIGHT.

LEFT

WHAT THE HELL ...

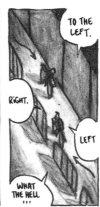

I TESTED THAT ONE A FEW TIMES.

TO CROSS THE STREET: WAIT FOR A SMALL BREAK IN THE FLOW AND INSERT A WHEEL ...

TRAFFIC WILL MOVE OUT AHEAD OF YOU IN AN EFFORT TO PUSH YOU BACK...

PROCEED WITH DETERMINATION... THE FLOW WILL NOW MOVE OUT BEHIND YOU ...

THE WORST IS OVER, YOU'RE DOING FINE.

BIKES ARE A SOLUTION THAT'S PERFECTLY ADAPTED TO CITIES.

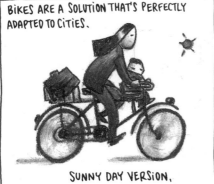

SUNNY DAY VERSION,

A STAY IN CHINA WOULD CONVINCE EVEN THE DIE-HARD SKEPTIC.

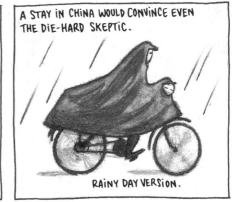

RAINY DAY VERSION.

BEFORE REACHING THE HOTEL, THE STREET SLOPES GENTLY FOR A HALF MILE. YOU CAN LET YOURSELF GO; NOBODY PEDALS.

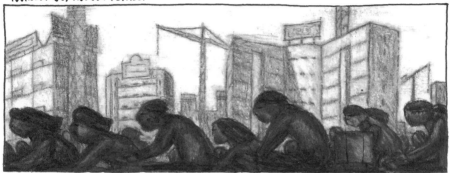

THE VISUAL EFFECT IS DISTURBING SINCE WE'RE ALL STATIONARY BUT MOVING FORWARD.

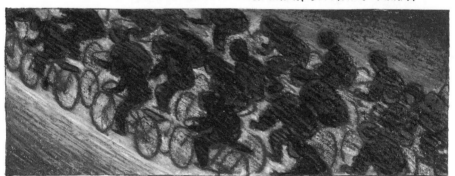

I GET THE STRANGE IMPRESSION THAT THE STREET ITSELF IS MOVING. IT'S LIKE THE WORLD IS SPINNING UNDER OUR WHEELS WITHOUT MANAGING TO PULL US ALONG.

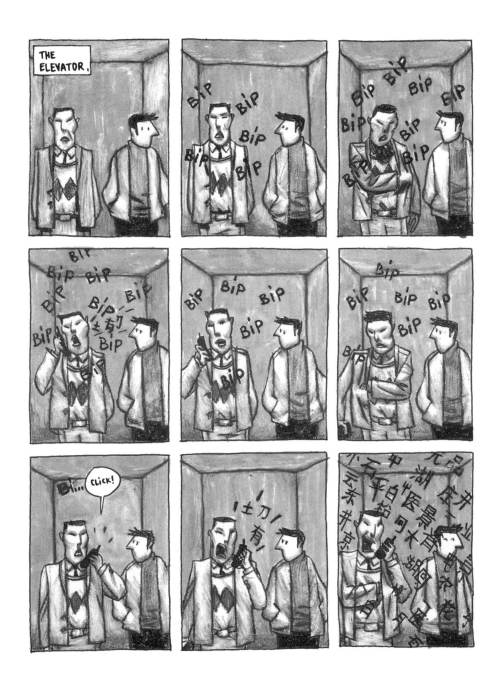

WITH NO HOT WATER LEFT FOR MY SOUP, I GO GET SOME IN THE HALL...

WHOA!

稀!

RIGHT IN FRONT OF MY DOOR!

MUST BE SOME HARMLESS FORM OF TAI CHI.

I HOPE...

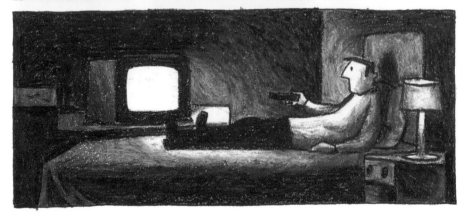

THE TV PICKS UP TWO KINDS OF CHANNELS ...

IF YOU SEE SMILING WORKERS TALKING TO JOURNALISTS, IT'S THE NATIONAL CHANNEL ...

IF YOU'VE GOT A SUPERMODEL AVOIDING JOURNALISTS AS SHE WALKS DOWN THE STEPS OF THE OPERA, A SWISS WATCH ON HER WRIST, IT'S THE HONG KONG CHANNEL.

HMM! IT'S CHANGING COLOR...

TOC TOC TOC

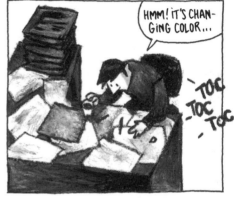

ONE GUY AT THE STUDIO WAS A LIVING CARICATURE OF THE CHINESE STEREOTYPE, GLASSES AND ALL.

AND SINCE HE REALLY WAS SHORT, HE WORE HIS HAIR STRAIGHT UP FOR THE EXTRA HEIGHT.

ERASERHEAD STYLE,

TODAY'S THE DAY. AFTER WORK, I'M GATHERING UP MY COURAGE TO JOIN THE LOCAL GOLD'S GYM... IT'LL GIVE ME SOMETHING TO DO IN THE EVENINGS.

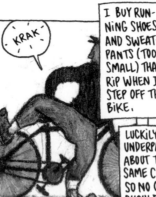

· KRAK ·

I BUY RUN-NING SHOES AND SWEAT-PANTS (TOO SMALL) THAT RIP WHEN I STEP OFF THE BIKE.

LUCKILY MY UNDERPANTS ARE ABOUT THE SAME COLOR SO NO ONE SHOULD NOTICE.

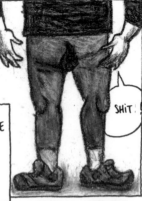

SHIT!

AT THE FRONT DESK, IT TAKES ALL OF FOUR GIRLS, LAUGHING HYSTERICALLY, TO GET ME SIGNED UP.

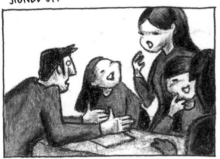

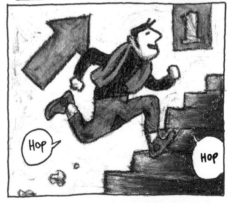

HOP

HOP

PFF PFF PFF PFF

THE WEIGHT ROOM IS FULL OF PEOPLE. DAMN, I THOUGHT IT WOULD BE QUIET. I DON'T HAVE A CLUE HOW TO USE THE EQUIPMENT. EVEN THOUGH I PEDAL ALL DAY, I FALL BACK ON THE BIKES FOR CREDIBILITY.

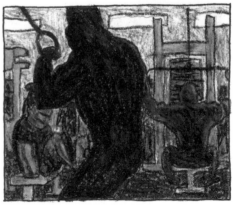

AFTER WATCHING CAREFULLY, I TRY THE TREADMILL ...

BUT I CAN'T GET IT STARTED!

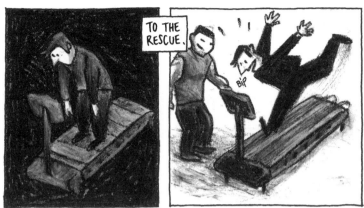

TO THE RESCUE.

BIP

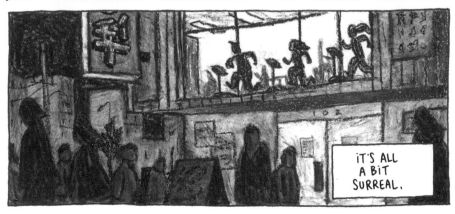

IT'S ALL A BIT SURREAL.

BEFORE LONG I'M TOTALLY EXHAUSTED, BUT I GET A SECOND WIND AND CONTINUE,

A BIT WILD-EYED, STARING INTENTLY AT A PLANT UP AHEAD THAT, AFTER A FEW

LONG MINUTES, SEEMS TO BE BOUNCING UP AND DOWN AT THE SAME PACE AS ME.

I FIND A TAIWANESE RESTAURANT BY THE GYM. UNLIKE MOST PLACES HERE, IT DOESN'T HAVE THOSE BLOODCURDLING FLUORESCENT LAMPS; THE LIGHTING IS SUBDUED.

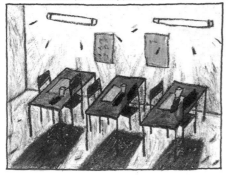

THE SERVICE IS EXCELLENT TOO, AND IT COMES WITH A SMILE.

I GO BACK EVERY NIGHT FOR A WEEK.

I MEET A LOCAL WHO SPEAKS AN APPROXIMATION OF ENGLISH AND PREDICTABLY HANDS ME HIS BUSINESS CARD.

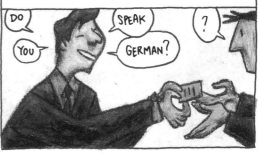

HIS GERMAN, ON THE OTHER HAND, IS IMPECCABLE —THE PRODUCT OF YEARS OF STUDY— BUT HE HAS NEVER MET A NATIVE SPEAKER.

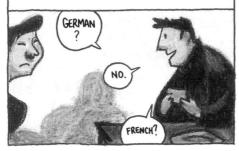

OH WELL.

THERE ARE DAYS WHEN I DON'T SAY A SINGLE WORD.

AT WORK, I WRITE OUT MY IN-STRUCTIONS...

THE ARM HAS TO DRAG ALONG FOR 4 FRAMES SO EVERY-THING DOESN'T STOP AT ONCE.

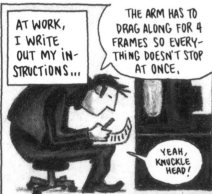

YEAH, KNUCKLE HEAD!

AFTER THEY'RE TRANSLATED, IF THERE ARE NO QUESTIONS AND EVERYTHING IS CLEAR, I DON'T MEET THE ANIMATORS.

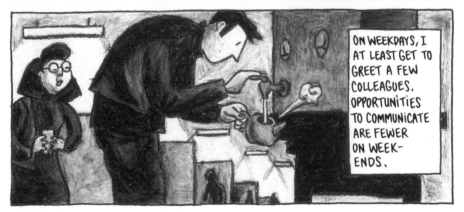

ON WEEKDAYS, I AT LEAST GET TO GREET A FEW COLLEAGUES. OPPORTUNITIES TO COMMUNICATE ARE FEWER ON WEEK-ENDS.

A STRANGE PATTER STARTS UP IN MY HEAD...

THERE YOU GO! ANOTHER FLOOR ...

ONE A DAY, UP TO THE SKY.

HEY! WHO'S STEALING MANHOLE COVERS NOW?

THAT'S JUST GREAT FOR CYCLISTS ...

IT'S LIKE A MOVIE WHERE YOU HEAR THE PROTAGONIST'S THOUGHTS IN VOICE-OVER.

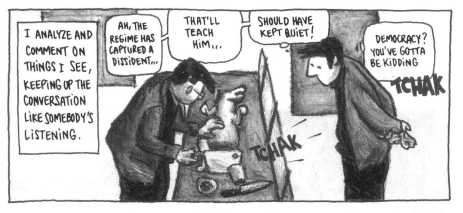

I ANALYZE AND COMMENT ON THINGS I SEE, KEEPING UP THE CONVERSATION LIKE SOMEBODY'S LISTENING.

AH, THE REGIME HAS CAPTURED A DISSIDENT...

THAT'LL TEACH HIM...

SHOULD HAVE KEPT QUIET!

DEMOCRACY? YOU'VE GOTTA BE KIDDING

TCHAK

TCHAK

THERE'S A SHIFT, AND I'M BOTH NARRATOR AND SPECTATOR.

I NOTICE THAT OLD EXPRESSIONS FROM BACK HOME HAVE STARTED CROPPING UP...

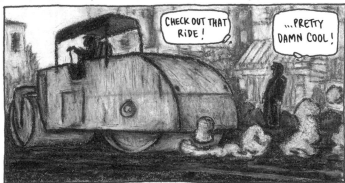

CHECK OUT THAT RIDE!

...PRETTY DAMN COOL!

SOMETIMES I CRACK MYSELF UP,

mpff...

THIS HAS NEVER HAPPENED TO ME ANYWHERE ELSE,

pfft...

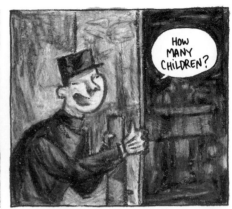

HOW MANY CHILDREN?

EVEN IF I LEAVE A MESS IN THE MORNING, WHEN I COME BACK, THE ROOM IS JUST LIKE IT WAS BEFORE.

IT MAKES ME FEEL LIKE TIME HAS STOPPED...

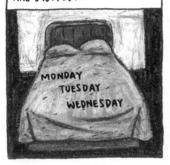

MONDAY
TUESDAY
WEDNESDAY

OR LIKE THE DAY KEEPS REPEATING ITSELF.

MONDAY
MONDAY
MONDAY

TIME IS HARDLY MOVING AS IT IS.

THE WORST IS WHEN MY JEANS COME BACK FROM THE CLEANER'S WITH A CREASE,

NOT AGAIN!

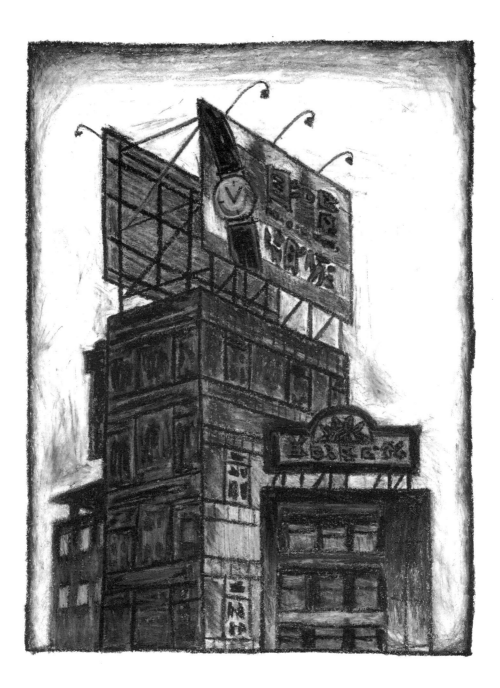

I'VE INVITED MY TRANSLATOR TO LUNCH AT A RESTAURANT I NOTICED YESTERDAY.

THIS WAY I CAN TRY NEW RESTAURANTS WITHOUT THE KIND OF NASTY SURPRISE I HAD LAST NIGHT:

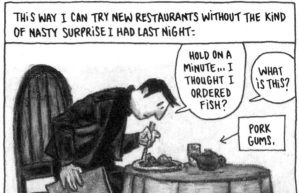

HOLD ON A MINUTE... I THOUGHT I ORDERED FISH?

WHAT IS THIS?

PORK GUMS.

TODAY I'M IN FOR A NICE SURPRISE: THE PLACE IS A KIND OF CAFETERIA WITH A COOK FOR EACH SPECIALTY, AND I CAN ACTUALLY SEE THE FOOD BEFORE EATING IT, WONDERFUL! I COME BACK OFTEN, AND SOON THE COOKS ALL KNOW ME.

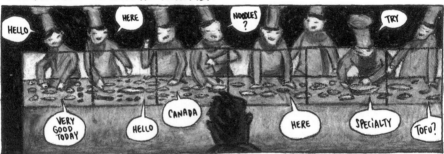

HELLO

HERE

NOODLES ?

TRY

VERY GOOD TODAY

HELLO

CANADA

HERE

SPECIALTY

TOFU?

NOODLES ARE MADE EVERY DAY.

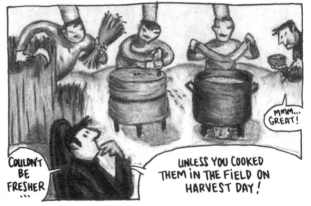

COULDN'T BE FRESHER...

MMM... GREAT!

UNLESS YOU COOKED THEM IN THE FIELD ON HARVEST DAY!

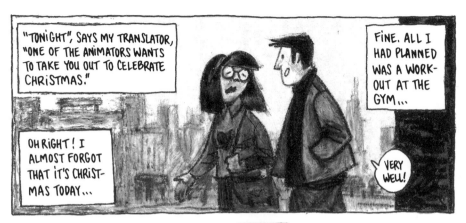

"TONIGHT", SAYS MY TRANSLATOR, "ONE OF THE ANIMATORS WANTS TO TAKE YOU OUT TO CELEBRATE CHRISTMAS."

OH RIGHT! I ALMOST FORGOT THAT IT'S CHRIST- MAS TODAY...

FINE. ALL I HAD PLANNED WAS A WORK- OUT AT THE GYM...

VERY WELL!

UP AHEAD, WE PASS BY A BILLBOARD I'VE ALWAYS WONDERED ABOUT. I ASK HER WHAT IT SAYS.

THOSE ARE POLICE SNAPSHOTS... YOU CAN SEE THE CRIMINALS THEY'VE CAUGHT...

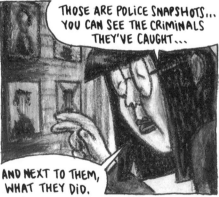

AND NEXT TO THEM, WHAT THEY DID.

I DON'T QUITE GRASP WHAT CRIMES THEY COMMITTED (THEFT? TRAFFICKING?) BUT I DO UNDERSTAND THAT THE ONES MARKED WITH A RED CROSS HAVE ALL BEEN EXECUTED.

ACCORDING TO OFFI-
CIAL SOURCES, THERE
WERE AN AVERAGE
OF FIVE CRIMINAL
CONVICTIONS A DAY
IN 1997. THE REAL
NUMBERS ARE PRO-
BABLY MUCH HIGHER.
THE EXACT NUMBER
OF EXECUTIONS IS A
STATE SECRET IN CHINA,

IT'S SAID THAT
CHINESE
AUTHORITIES ARE
CYNICAL ENOUGH
TO CHARGE
FAMILIES THE
PRICE OF THE
BULLET USED
FOR THE
EXECUTION.

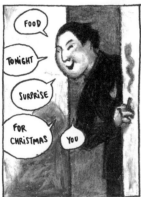

FOOD

TONIGHT

SURPRISE

FOR CHRISTMAS YOU

AS PREDICTED, AN ANIMATOR
INVITES ME TO SUPPER AT THE
END OF THE DAY...

OH!

IT'S A GOOD SURPRISE. THANK YOU!

LUCKILY, MY TRANSLATOR IS
ALSO INVITED...

IT'S A NORTHERN SPECIALTY.

?

CRABMEAT
IN ASPIC
SERVED WITH
SPICY
PEANUT
SAUCE.

BEEF
DUMPLINGS
WITH FIVE
SPICES.

PIECES OF CARA-
MALIZED
POTATO DIPPED
IN COLD WATER
TO HARDEN
AND CRACK
THE STRANDS
OF SUGAR.

DEEP-FRIED
RIBS (WITH LOTS
OF FAT).
MMM...

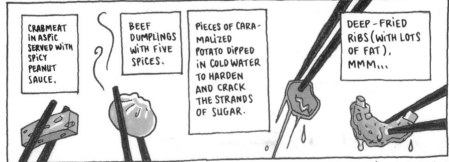

IT WAS EXCELLENT. AFTER THE MEAL, WE WERE SUPPOSED TO STOP BY THE "ENGLISH CORNER": A
PLACE WHERE I WOULD BE ABLE TO MEET AND TALK WITH LOCALS.

IT'S FOR CHINESE TO PRACTICE ENGLISH.

VERY GOOD

YOU'D THINK SOMEBODY WOULD HAVE MENTIONED IT BEFORE.

I EVEN ASKED THEM — RIGHT FROM THE START.

WE'RE OUT OF LUCK. IT'S SHUT. I WENT BACK A FEW TIMES, BUT IT WAS NEVER OPEN.

WHAT NOW? TO END THE EVENING, I INVITE THEM TO THE HOTEL FOR A DRINK.

FIRST THEY SAY YES... THEN THEY TALK IT OVER AND CHANGE THEIR MINDS.

WE'RE GOING TO HAVE A DRINK AT MR. LIN THE ANIMATOR'S, INSTEAD....

OK, LET'S GO!

THE TRANSLATOR HAD TO GO HOME, SO WE'RE ON OUR OWN...

VERY FAR ?

OK.

OUR JOURNEY IS NEVER-ENDING. WE'RE IN THE OUTSKIRTS OF THE CITY NOW. THERE ARE NO STREETLIGHTS... YOU CAN'T SEE MUCH.

WE GET OFF IN THE MIDDLE OF A CONSTRUCTION SITE.

THERE'S A GROUP OF BUILDINGS, AND MANY PEOPLE.

HIS APARTMENT IS ON THE FIFTH FLOOR. ALL THE DOORS HAVE BARS.

SAME HOMEY DETAIL ON THE WINDOWS.

THERE IS NO DECOR. THE HOSPITAL-GREEN WALLS ARE NEON-LIT. IT'S TOTALLY BARE EXCEPT FOR A HUGE LEATHER SOFA FACING AN EQUALLY HUGE TELEVISION THAT HE TURNS ON THE MOMENT WE WALK IN.

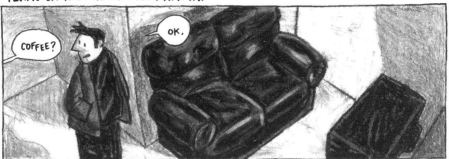

A STRANGE POSTER IS TACKED OVER THE TV.

IT'S A PHOTOGRAPH OF A FRENCH-STYLE TABLE SETTING, WITH LITTLE PLATES NESTED IN BIGGER ONES, A PORCELAIN TUREEN, SILVER CUTLERY, ETC. — ALL THINGS YOU NEVER SEE HERE... IT MUST SEEM EXOTIC TO HIM.

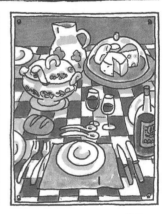

THE COFFEE LOOKS DUBIOUS. BEING A GOOD HOST, HE MIGHT HAVE OVER-DONE IT.

MUDDY LUMPS FLOAT ON THE SURFACE.

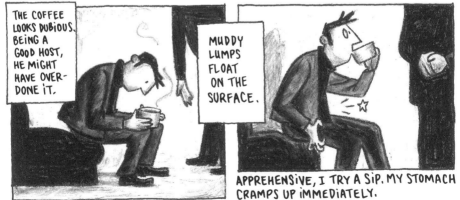

APPREHENSIVE, I TRY A SIP. MY STOMACH CRAMPS UP IMMEDIATELY.

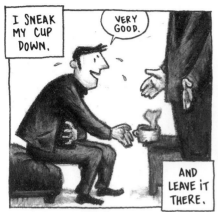

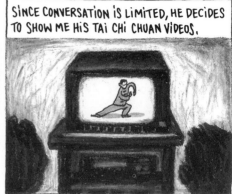

THE NEW-AGE MUSIC PLAYING QUIETLY IN THE BACKGROUND HAS A SOOTHING EFFECT.

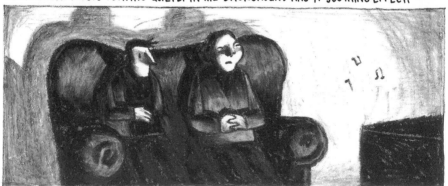

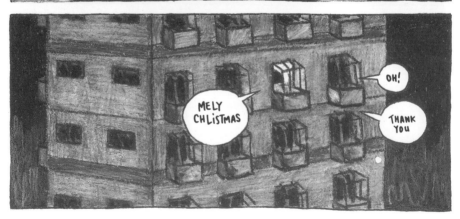

MIDWAY THROUGH THE VIDEO, HE REALIZES THAT I WON'T BE DRINKING HIS COFFEE.

SORRY, I HAVE NO TEA!

IT'S OKAY.

NO PROBLEM!

BUT IT IS FOR HIM. HE STARTS CALLING HIS FRIENDS TO FIND SOME.

HE FINALLY GIVES UP.

NO TEA!

HE SHOWS ME PICTURES HE PAINTED BACK WHEN HE TAUGHT FINE ARTS IN BEIJING.

NICE...

WE TALK PAINTING, AND HE TELLS ME ABOUT AN ARTIST HE REALLY LIKES.

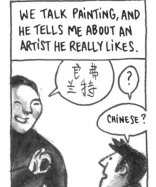

?

CHINESE?

TURNS OUT HE MEANS REMBRANDT, BUT IN CHINESE IT DOESN'T SOUND THE SAME.

A LITTLE BLACK AND WHITE REPRODUCTION IN A CATALOGUE IS ALL HE HAS ON HIS FAVORITE PAINTER...

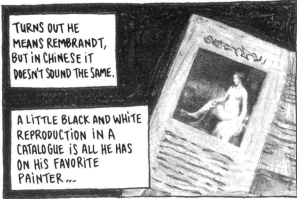

EVEN FOR A FINE ARTS PROFESSOR, FINDING BOOKS WITH FULL COLOR REPRODUCTIONS ISN'T EASY.

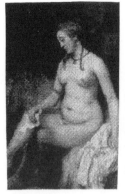

WITH CHRISTMAS SETTING THE MOOD, I TELL HIM THE STORY DEPICTED IN HIS FAVORITE PAINTING.

BEAUTIFUL BATHSHEBA HAS JUST STEPPED OUT OF HER BATH AND RECEIVED A MESSAGE SUMMONING HER TO KING DAVID. HER GAZE IS AVERTED; SHE SEEMS LOST IN THOUGHT; SHE LOOKS SAD BECAUSE SHE SENSES MISFORTUNE AHEAD... BUT NO ONE CAN REFUSE A KING.

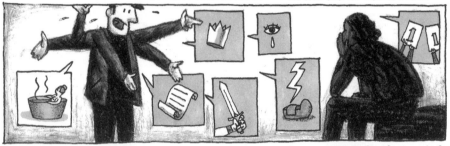

TO MARRY BATHSHEBA, DAVID SENDS HER HUSBAND TO DIE IN BATTLE, AND TO PUNISH THE KING, YAHWEH CAUSES THEIR FIRST CHILD TO DIE... THAT MAKES THEM EVEN.

IT'S ALWAYS SURPRISING TO SEE WHAT YOU CAN GET ACROSS WITH A DOZEN WORDS AND LOTS OF GESTICULATING.

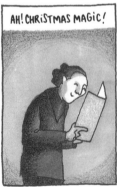

AH! CHRISTMAS MAGIC!

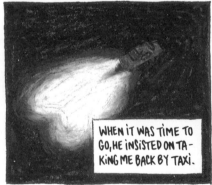

WHEN IT WAS TIME TO GO, HE INSISTED ON TAKING ME BACK BY TAXI.

ALL THAT ATTENTION FROM SOMEONE I HARDLY KNEW, JUST SO I COULD HAVE A MERRY CHRISTMAS, WAS TOUCHING.

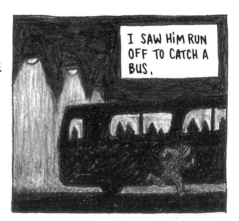

I SAW HIM RUN OFF TO CATCH A BUS.

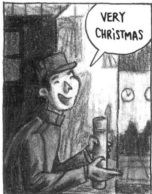

VERY CHRISTMAS

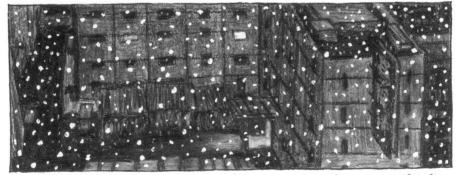

I WONDERED WHETHER THEY'D HAD SNOW BACK HOME FOR CHRISTMAS — I HOPED SO — CHRISTMAS IS ALWAYS NICER WHEN IT SNOWS...

THIS WEEK CRAWLS ALONG LIKE ALL THE OTHERS.

EVENINGS, I DRAW. I HAVE TO FINISH A STORY FOR LAPIN NR. 17.*

I'M USING REAL INDIA INK FOR THE FIRST TIME.

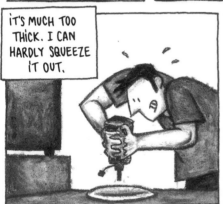

IT'S MUCH TOO THICK. I CAN HARDLY SQUEEZE IT OUT.

STRANGER STILL, IT'S PERFUMED.

SNIFF! SNIFF!

TOC TOC TOC

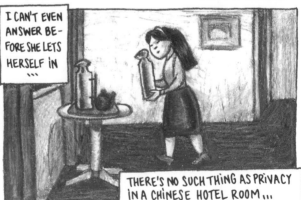

I CAN'T EVEN ANSWER BEFORE SHE LETS HERSELF IN ...

THERE'S NO SUCH THING AS PRIVACY IN A CHINESE HOTEL ROOM ...

* FRENCH COMICS ANTHOLOGY PUBLISHED BY L'ASSOCIATION.

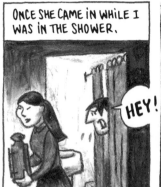

ONCE SHE CAME IN WHILE I WAS IN THE SHOWER.

HEY!

ANOTHER TIME, I CAME BACK FOR SOME PAPERS I HAD FORGOTTEN.

IT'S LIKE THE WIRE ON MY CD PLAYER...

I FIGURED A MOUSE WAS RESPONSIBLE UNTIL I REALIZED THAT THE MAID HAD SINGED IT ON THE LIGHT BULB WHILE CLEANING.

I WONDER WHAT SHE THOUGHT OF THE LATEST PORTISHEAD CD.

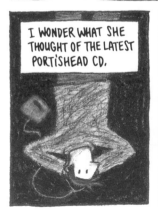

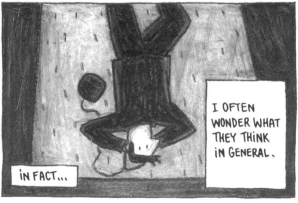

IN FACT...

I OFTEN WONDER WHAT THEY THINK IN GENERAL.

NEAR SHENZHEN, THERE'S A TOWN YOU CAN GET TO BY BUS THAT'S SUPPOSED TO HAVE MANY FOREIGNERS.

THIS SATURDAY, I'M DETERMINED TO GO.

I'D BEEN TOLD WHERE TO WAIT AND WHICH BUS TO TAKE.

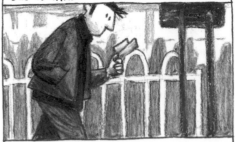

ON A SCRAP OF PAPER: MY DESTINATION IN CHINESE.

HERE, THE SUN IS A NUISANCE.

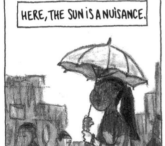

PEOPLE SHIELD THEMSELVES LIKE IT'S RADIOACTIVE ...

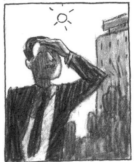

ESPECIALLY THE GIRLS.

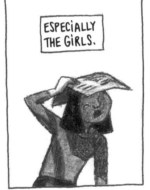

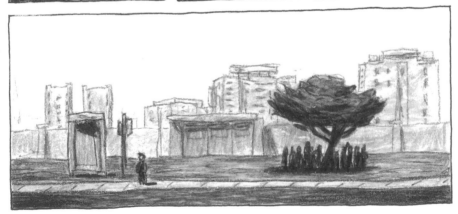

WHAT NOW? THERE'S NOTHING TO DO BUT WORK OUT AT THE GYM. I GO THROUGH THE MOTIONS, BUT MY HEART ISN'T IN IT: I CAN'T GET MOTIVATED.

ONE THING'S SURE: I'M GOING TO HONG KONG NEXT WEEKEND.

AT LEAST I'LL BE ABLE TO COMMU-NICATE THERE.

IT SEEMS SO TOTALLY POINTLESS...

ALL THIS SOPHISTICATED EQUIPMENT TO WORK UP A SWEAT IN MUSCLES I'LL NEVER USE FOR ANY-THING ELSE.

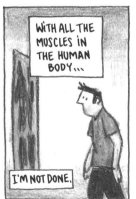

WITH ALL THE MUSCLES IN THE HUMAN BODY...

I'M NOT DONE.

MAYBE I COULD PICK ONE THAT NOBODY HAS EVER THOUGHT OF DEVELOPING AND REALLY FOCUS ON IT...

I KNOW: THE FUNNY BONE! WITH A BIT OF EXERCISE, IT MIGHT HURT LESS WHEN IT GETS BUMPED.

THEY SHOULD INVENT A MACHINE THAT WORKS ONLY THE FUNNY BONE.

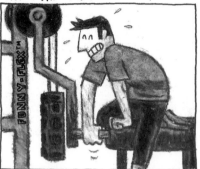

AFTER TRAINING HARD FOR A FEW WEEKS, I COULD SHOW OFF AT CAFÉS.

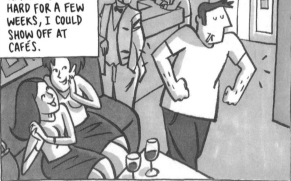

IN THE LOCKER ROOM, I CHAT WITH AN AMERICAN WHO HAS BEEN WORKING HERE FOR A FEW MONTHS.

HE'S GOT TO BE THE ONLY MAN IN ALL OF CHINA WHO DOES AEROBICS.

WE END THE EVENING AT A RESTAURANT HE LIKES.

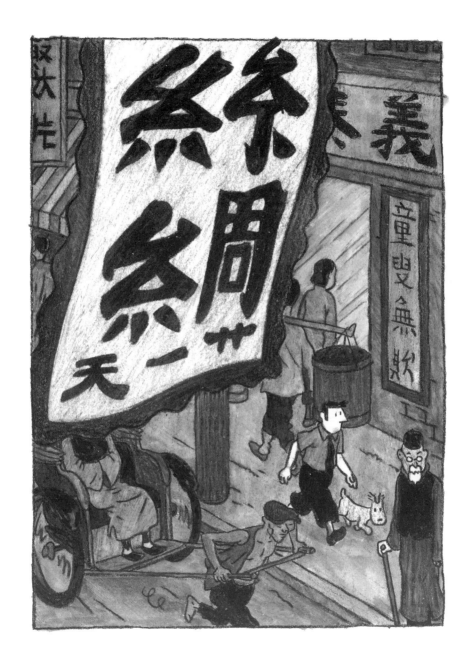

EVEN THOUGH HONG KONG, SINCE REUNIFICATION, IS ONCE AGAIN PART OF THE MIDDLE KINGDOM, YOU HAVE TO GO THROUGH PASSPORT CONTROLS ON BOTH SIDES OF THE BORDER.

 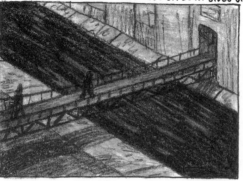 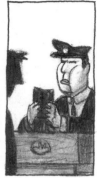

YOU THEN CROSS A NO-MAN'S LAND BY TRAIN FOR OVER AN HOUR TO GET TO THE FIRST SUBWAY STATION IN THE NEW TERRITORIES (NORTH OF HONG KONG).

EVERYTHING IS CLEAN, THE KIDS ARE HIP (THEY WEAR THEIR JEANS LIKE LUCKY LUKE), I CAN READ ALL THE ADS ON THE WALLS... IT'S REVERSE CULTURE SHOCK.

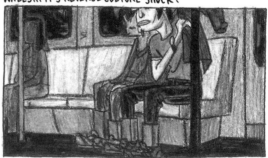

AND WONDER OF WONDERS, I BLEND IN UNNOTICED!

THE WEEKEND IS ALREADY A TOTAL SUCCESS.

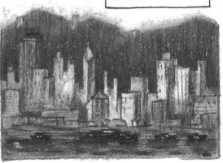

HONG KONG IS SOMETHING LIKE A TROPICAL NEW YORK. THE PACE HERE REMINDS ME OF WESTERN CITIES: THERE ARE CAFÉS, BOOKSHOPS, MOVIE THEATRES, ALL KINDS OF BOUTIQUES, A BOTANICAL GARDEN...

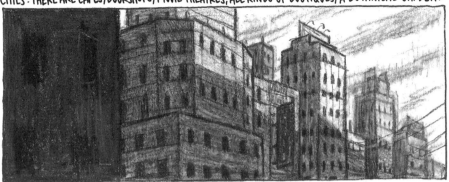

AT THE MOVIES, YOU CHOOSE YOUR SEAT...

UH... B7

AT THE RECORD SHOP, I BUY A PASCAL COMELADE CD THAT'S PLAYING. HE'S HUGE HERE...

IN THE BOUTIQUES, EVEN THE XL SHIRTS ARE TOO TIGHT...

IN A BOOKSHOP, I FIND A SHERLOCK HOLMES ADVENTURE SET IN A KIND OF SINO-LONDON.

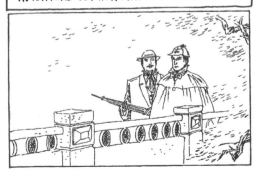

I FEEL LIKE TINTIN.

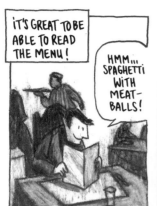

IT'S GREAT TO BE ABLE TO READ THE MENU!

HMM... SPAGHETTI WITH MEAT-BALLS!

I STROLL AIMLESSLY THROUGH THE CITY, A BLISSFUL SMILE STUCK TO MY FACE.

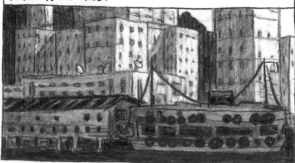

THERE ARE MANY TOURIST ATTRACTIONS. I DECIDE TO TAKE A RIDE ON THE TRAM THAT GOES UP TO THE ISLAND'S PEAK.

WE CLIMB STEEPLY AT ALMOST 45°!

CLAK CLAK CLAC CLAC CLAC

IF IT BREAKS DOWN, WE'RE TOAST!

CLAK CLAC CLAC CLAC

CLAC CLIC CLAC CLIC CLAC

THERE'S NO EMERGENCY EXIT...

CLIC CLAC CLIC CLAC

AND THE WINDOWS DON'T OPEN!

CLAC CLIC CLAC C

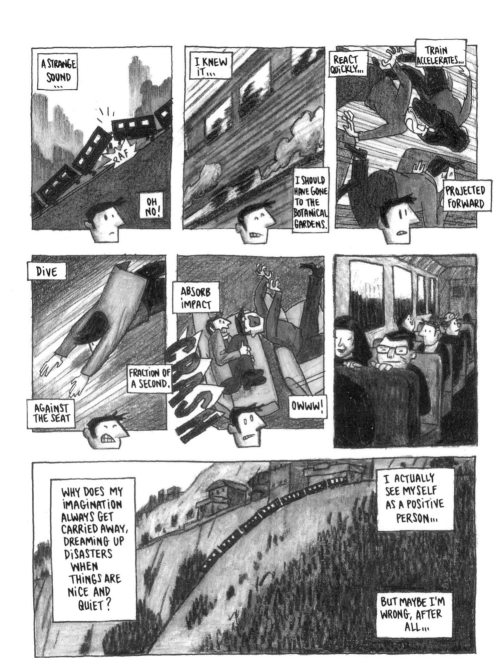

THE PEAK OFFERS GREAT PANORAMIC VIEWS OF THE CITY.

THE PERFECT PLACE TO BE PHOTOGRAPHED.

THERE'S EVEN A GUY WHO DOES JUST THAT.

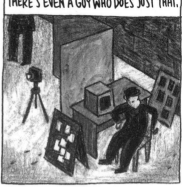

STRANGELY ENOUGH, HE HAS HIS CLIENTS POSE AGAINST A BLUE BACKDROP.

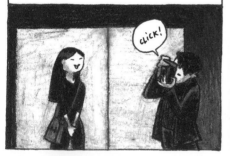

click!

HE THEN USES A COMPUTER TO OVERLAY A PHOTO OF THE CITY, EVEN THOUGH IT'S RIGHT IN FRONT OF HIM.

NOT QUITE REAL, NOT REALLY FAKE. A SLIGHT DEVIATION FROM REALITY. WHAT A CONCEPT!

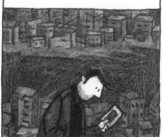

106

AT THE SUMMIT, THERE'S AN ENTERTAINING FOUNTAIN THAT SPOUTS JETS OF WATER IN A REGULAR RHYTHM.

ANIMATOR'S REFLEX: I TRY TO BREAK DOWN THE MESMERIZING MOVEMENT, WHICH KEEPS REPEATING ITSELF...

SURPRISINGLY, GIVEN THE FORCE OF THE WATER, THE FIRST KEY NEEDS TO BE LOCATED NEAR THE TOP OF THE TRAJECTORY.

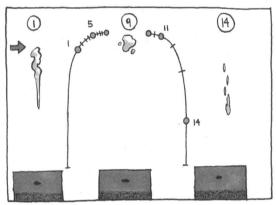

EVEN IF YOU WATCH CARE- FULLY, YOU CAN'T SEE THE WATER EMERGE FROM THE HOLE.

AFTER A NIGHT'S SLEEP, I GO DOWN TO THE PARK NEXT TO THE HOTEL. I FIND A BENCH NEAR A MAGNIFICENT CENTURY-OLD BANYAN TREE AND START TO DRAW IT...

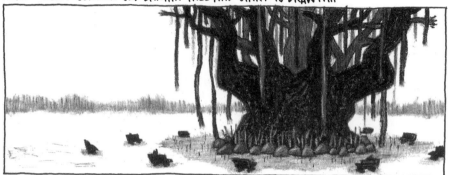

UP AHEAD, ON ANOTHER BENCH, A MAN WITH A MIRROR USES NAIL CLIPPERS TO SHAVE THE FEW HAIRS ON HIS CHIN.

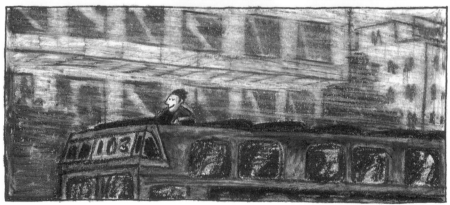

ON HONG KONG ISLAND, THE CONCEPT OF YIN AND YANG IS A PALPABLE GEOGRAPHIC FACT...

ONE SIDE IS FULL-OUT URBAN WITH ITS SKYSCRAPERS; THE OTHER, TEN MINUTES BY BUS, HAS BEACHES WITH SAND TO DIG YOUR TOES INTO.

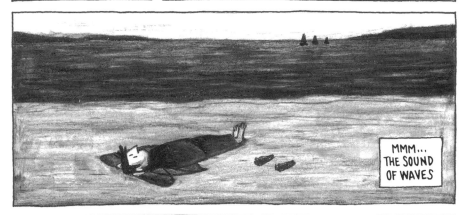

MMM... THE SOUND OF WAVES

IF I COULD JUST FORGET THAT I'M GOING BACK TO SHENZHEN IN LESS THAN AN HOUR, I MIGHT EVEN BE ABLE TO RELAX.

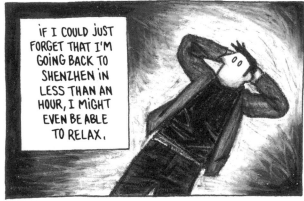

A YOUNG BUSINESSMAN BORROWS A PEN TO FILL OUT HIS VISA PAPERS.

AS HE GIVES IT BACK, THE PEN SLIPS AND FALLS. HE PICKS IT UP AND HANDS IT TO ME.

OOPS! SORRY!

THANK YOU!

SIX FINGERS!...HE HAD SIX FINGERS!

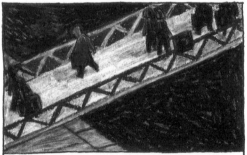

IT LOOKED LIKE A SECOND, SMALLER THUMB, GRAFTED ONTO THE FIRST.

COME TO THINK OF IT, BACK HOME YOU'D SAY A CLUMSY PERSON IS ALL THUMBS...

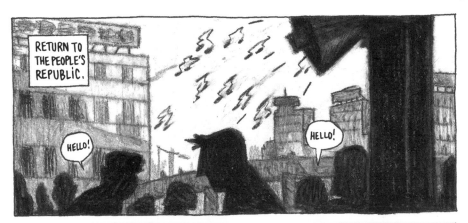

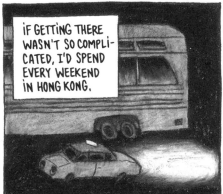

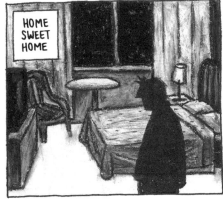

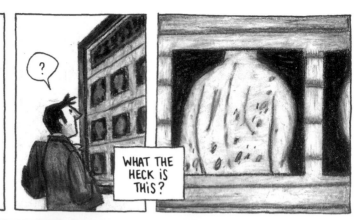

THAT MORNING, I WAS WEARING MY VIETNAM T-SHIRT...

VIET-NAM FLAG?

YES... COMMUNIST STAR.

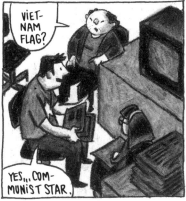

FOR ONCE I GET A CHANCE TO TALK ABOUT SOMETHING OTHER THAN ANIMATION...

IN FRANCE WE HAVE COMMUNISTS IN THE GOVERNMENT.

OF COURSE, HE RESPONDS BY LAUGHING

...

IN CHINA, LAUGHTER MASKS A VARIETY OF EMOTIONS THAT ARE DIFFICULT FOR FOREIGNERS TO INTERPRET.

I'M AFRAID OF COMMUNISTS.

THAT WAS THE ONLY POLITICAL STATEMENT I HEARD DURING THE WHOLE OF MY STAY...

BUT THEN, I NEVER PRODDED, EITHER. GIVEN THEIR SITUATION, DISTRUST SEEMS PERFECTLY JUSTIFIED.

AT THE RATE THAT WE'RE GOING, I DOUBT WE'LL BE ABLE TO WRAP UP THE SERIES BEFORE I LEAVE...

I'M HOPING THEY DON'T ASK ME TO STAY ON...

I RUN INTO MR. LIN AT THE HOT WATER DISPENSER AND GIVE HIM A BOOK ON REMBRANDT I HAD BROUGHT BACK FROM MY WEEKEND IN HONG KONG...

HE SEEMS NEITHER SURPRISED NOR PLEASED, HE JUST SAYS:

THANK YOU!

...AND GETS BACK TO WORK.

NEXT DAY, HE REAPPEARS WITH A BOOK OF SKETCHES FOR ME BY A CHINESE ARTIST I HAD ADMIRED AT HIS PLACE,

I ALSO GIVE AN ENGLISH NOVEL TO MY TRANSLATOR...

THANK YOU!

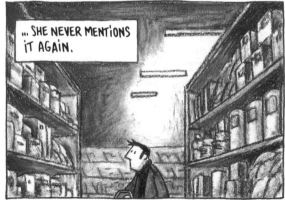

... SHE NEVER MENTIONS IT AGAIN.

I SPEND MOST OF MY EVENINGS READING, WORKING OUT AND WANDERING THROUGH SUPERMARKETS...

THEY'RE A NEW PHENOMENON HERE AND VERY LUXURIOUS. I SHOP WITH THE EMERGING BOURGEOISIE.

UNFORTUNATELY, THERE ARE TOO MANY WESTERN PRODUCTS.

I DO SOME RANDOM TESTING.

MMM... THATSH NUMMY!

I'LL BUY MORE TOMORROW

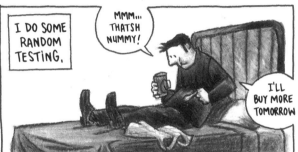

BESIDES WATCHING THE ADS ON LOCAL TV CHANNELS, IT'S THE MOST EXOTIC THING TO DO HERE.

FOR A WHILE, I TOURED THE BOOK-SHOPS LOOKING FOR ART BOOKS... AND FOUND A FEW TREASURES THAT HOLD A SPECIAL PLACE ON MY SHELVES.

OH BINGO!

"TOWN DWELLINGS" WANG CHI YUN

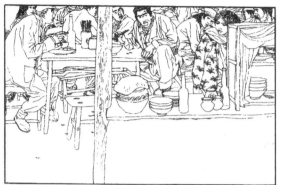
"IF I WERE THE DISTRICT MAYOR" HU BUO ZHONG

THE SENSE OF COMPOSITION IS AMAZING!... EVEN IF YOU CAN'T READ THE TEXT, YOU CAN FEEL THE PRESSURE WEIGHING ON THE GIRL.

MMM, VERY NICE MOVEMENT... TOO BAD YOU DON'T GET GRAPHICS LIKE THESE IN ANIMATION...

"HAI DEN, MASTER AND MONK"

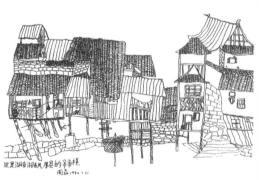
ANOTHER BOOK OF CHILDREN'S DRAWINGS

THIS USE OF CLEAN LINE WAS A BIG INSPIRATION ON MY FIRST TRIP TO CHINA... I EVEN DREW THE FIRST PAGES OF A BOOK I WANTED TO DO.

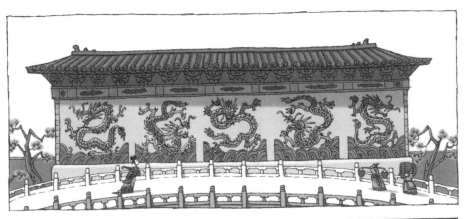

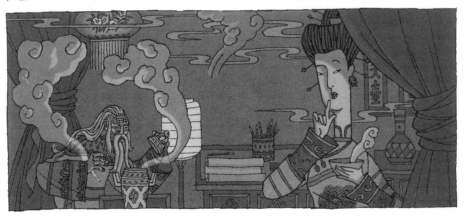

BUT I COULDN'T FIND A PUBLISHER, SO I LET IT DROP.

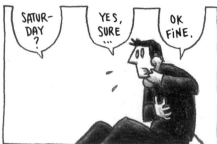

CHEUN INVITES ME TO SPEND SATURDAY WITH HIM AND HIS GIRLFRIEND, WHO STUDIES ENGLISH AT THE UNIVERSITY OF BEIJING.

I MEANT TO GO BACK TO CANTON BUT I'D RATHER STAY HERE AND MEET PEOPLE, JUST TO HAVE A CHANCE TO TALK.

AFTER THREE MONTHS OF BODYBUILDING, MY STOMACH ISN'T ANY FLATTER ...

IT'S JUST FIRMER, THAT'S ALL.

I GUESS NO MATTER WHAT YOU DO, SOME BELLIES ARE MADE TO LAST.

I REMEMBER THIS GUY FROM IRELAND...

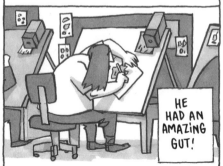

HE HAD AN AMAZING GUT!

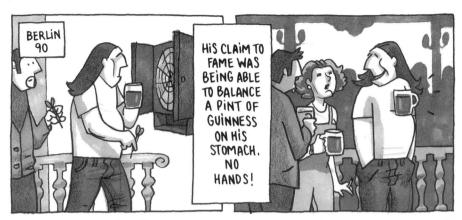

BERLIN 90

HIS CLAIM TO FAME WAS BEING ABLE TO BALANCE A PINT OF GUINNESS ON HIS STOMACH. NO HANDS!

TALK ABOUT GERMAN-STYLE DISCIPLINE... I'D NEVER SEEN A MORE CHAOTIC STUDIO. WE SWITCHED PRODUCERS THREE TIMES...

ON A CHART, WE'D CHECK OFF EVERY BEER WE TOOK FROM THE RESERVES.

AT MONTH'S END, THE ACCOUNTANT DEDUCTED THE TOTAL FROM OUR PAYCHECK...

ONE DAY, AN ANIMATOR WHO DIDN'T GET ALONG WITH MANAGEMENT CALLED US ALL OUT INTO THE PARKING LOT.

HE LIT A BONFIRE OF ALL THE EPISODES HE HAD DRAWN...

THEN DROVE OFF IN THE CAMPER HE LIVED IN.

I MEET TOM AS I LEAVE THE GYM AND WE GO FOR SUPPER.

LIKE ALL FOREIGNERS IN SHENZHEN, TOM WANTS TO CARVE OUT HIS OWN NICHE IN THE HUGE CHINESE MARKET. HE'S INTO E-COMMERCE AND THE INTERNET... IF HE MANAGES, HE'LL MAKE A FORTUNE.

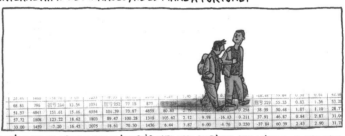

WHILE HE PANS FOR GOLD IN THIS NEW KLONDIKE, HIS WIFE AND KIDS IN CALIFORNIA KEEP IN TOUCH BY E-MAIL.

TOM SPEAKS CHINESE, WHICH IS HANDY...

SO IF YOU DON'T SPEAK CHINESE, YOU DON'T UNDERSTAND 'EM... AND IF YOU DO SPEAK IT, YOU STILL DON'T UNDERSTAND 'EM...

HM.

AT SOME POINT, HE'S TELLING ME WHY BIG MACS TASTE BETTER IN BIG CITIES THAN IN SMALL TOWNS.

TAKE CHICAGO...

BUT I CAN'T REMEMBER THE DETAILS

HEY, SOMEBODY TOOK OUT THE ROTTING PAPER FROM UNDER THE GLASS...

TOO BAD

TODAY, THERE ARE ONLY TWO DECENT SEQUENCES; THE REST ARE BAD...

SOME DAYS ARE LIKE THAT.

BUT THEN A SCENE IN THE LATEST STORYBOARD CHEERS ME UP.

HA HA HA!

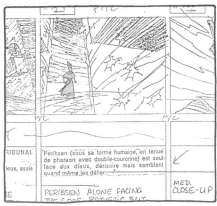

RIBUNAL

ieux, assis

'Péribsen (sous sa forme humaine, en tenue de pharaon avec double-couronne) est seul-face aux dieux, dérisoire mais semblant quand même les défier.

PERIBSEN ALONE FACING THE GODS. PATHETIC BUT

MED. CLOSE-UP

"PATHETIC BUT STILL LOOKING DEFIANT" HA HA HA! IT'S PAPYRUS MEETS BERGMAN! ...AND ALL THAT IN 50 IMAGES (2 SECONDS) USING A 12-FIELD FRAME. HA HA!

I GET A CALL FROM PARIS. THERE ARE TWO EPISODES LEFT TO SUPERVISE, BUT THEY'LL MANAGE BY FAX AND PHONE, I WON'T HAVE TO EXTEND MY STAY!

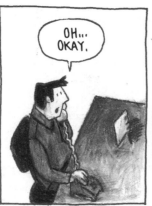

OH... OKAY.

HUH!

THOSE LAST TWO EPISODES ARE GOING TO BE HELL.

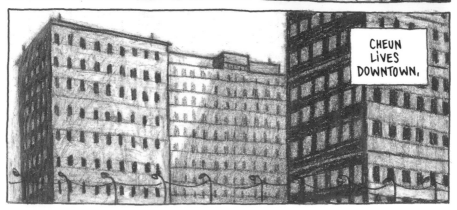

CHEUN LIVES DOWNTOWN.

THE FLAT IS ON LOAN FROM HIS COMPANY.

IT'S UNDECORATED; THE WALLS ARE ALL WHITE. IN THE LIVING ROOM, A HUGE BLACK LEATHER SOFA FACES A TV VCR WITH SPEAKERS.

HIS GIRLFRIEND OFFERS ME A NECTARINE AND WE EAT IN SILENCE, WATCHING A DOCUMENTARY ABOUT HURRICANES.

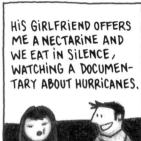

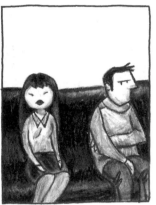

OUTSIDE, THE SUN IS SHINING.

THEN CHEUN SUGGESTS WE WATCH A DVD WITH HIGHLIGHTS OF MAGIC JOHNSON'S CARREER.

WELL, ACTUALLY...

WATCHING SPORTS ON TV ISN'T...

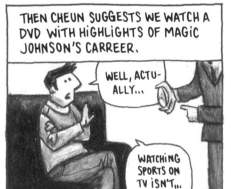

DO YOU WANT TO PLAY?

BASKETBALL?

YES

WHERE?

OUTSIDE.

YES SURE.

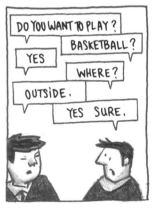

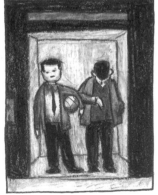

WE CAN'T PLAY LONG. THE SUN IS GOING DOWN.

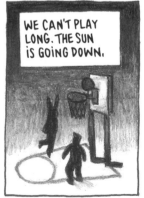

PEOPLE JOIN US AND WE HAVE A LITTLE GAME. FOR THE FIRST TIME IN MY LIFE, I'M THE TALLEST PERSON ON THE COURT.

I SCORE A BUNCH OF POINTS!

THEN BACK INSIDE FOR MORE TV WITH HIS MUTE GIRLFRIEND.

HUNGRY?

I'M HUNGRY EARLY...

TO PLEASE ME, CHEUN WANTS TO TREAT ME TO WESTERN FOOD: STEAK, HAMBURGER, FRIES, ETC....

LUCKILY, I MANAGE TO REDIRECT HIS PLANS BY SAYING I WANT TO EAT FISH.

I'M INVITED TO DELIVER THE LAST RITES.

UH... LET'S SEE... THAT ONE, THE BIG ONE!

AND THE ONE THAT'S TRYING TO HIDE THERE, TOO!

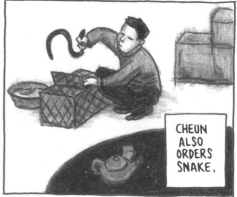

CHEUN ALSO ORDERS SNAKE.

124

THE WAITER RETURNS WITH TWO GLASSES. THE FIRST HAS A BIT OF ALCOHOL MIXED WITH SNAKE BLOOD.

IT DOESN'T LOOK APPETIZING, BUT IT GOES DOWN.

"VERY APHRODISIAC," CHEUN TELLS ME,

IT'S MAKING ME A NICE LEG!*

*FRENCH EXPRESSION: "FAT LOT OF GOOD THAT'LL DO ME."

A PIECE OF SNAKE ENTRAILS (THE BLADDER, I THINK) IS FLOATING IN THE SECOND GLASS.

CHEUN MASHES IT WITH HIS SPOON. A GREEN LIQUID LEAKS OUT, GIVING THE CONTENTS A NICE ABSINTHE COLOR.

THIS ONE IS VERY GOOD FOR THE CIRCULATION, I'M TOLD.

THE TASTE, THOUGH, IS REVOLTING. IT'S ONE OF THE FEW FOODS I DIDN'T ENJOY IN CHINA.

BUT EATING REMAINED THE BIGGEST PLEASURE OF MY STAY,

AFTER THE MEAL, THEY TAKE ME BACK TO THE HOTEL.

HIS GIRLFRIEND HADN'T SAID A DOZEN WORDS ALL NIGHT.

HEY! I OPENED THE DOOR ON MY OWN!

IN THREE MONTHS, I'VE NEVER TOUCHED THAT KNOB!

COLONIAL REFLEXES KICK IN AND I THINK: "WHERE'S THE DOORMAN? HE'S NOT DOING HIS JOB..."

ONE MORE WEEK... IT'S TIME TO GO: I'M PICKING UP BAD HABITS.

THAT NIGHT, WATCHING A FRESHLY PIRATED FILM PLAYING ON THE HOTEL'S CLOSED CIRCUIT TV, I EAT A WHOLE BAG OF SOUR-TASTING SEEDS.

IT'S THE LATEST JAMES BOND. THE FILM WAS TAPED IN A MOVIE THEATRE USING A CAM-CORDER... YOU CAN SEE THE HEADS OF THE PEOPLE IN THE FRONT ROW AND HEAR THEM LAUGHING.

AT ONE POINT, THE CAMERA TILTS TO ONE SIDE.

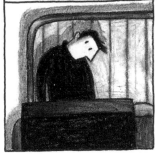

NEXT DAY, MY LIPS ARE SWOLLEN AND MY TONGUE IS TINGLING.

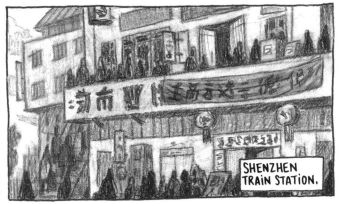

SHENZHEN TRAIN STATION.

I THOUGHT I WAS PROPERLY PREPARED.

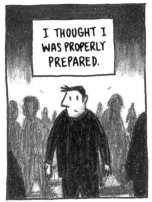

I HAD KEPT MY OLD TICKET, I HAD CHECKED THE SCHEDULE. I'D EVEN COME BACK TO FIND THE WICKET FOR THE TRAIN TO CANTON.

BUT TODAY, IT'S SHUT.

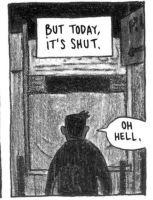

OH HELL.

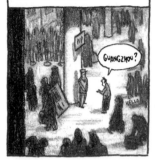

I TRY TO GET INFORMATION OUT OF A COP.

GUANGZHOU?

HELLO

HE GIVES ME VAGUE DIRECTIONS...

THERE?
STRAIGHT AHEAD?
TO THE LEFT? WHERE?

I TRY ANOTHER WICKET AT RANDOM...

SUPER!

WHERE?
THERE?
I DON'T SEE IT!
HELLO

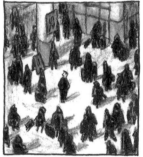

THIS IS ABSURD. ALL I WANTED WAS TO SPEND MY LAST WEEK-END IN CANTON.

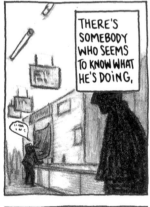

THERE'S SOMEBODY WHO SEEMS TO KNOW WHAT HE'S DOING.

GUANGZHOU

BINGO!

IN CANTON, I GET OUT AT THE YOUTH HOSTEL.

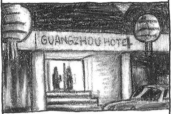

IT'S GOT SINGLE ROOMS THAT AREN'T EXPENSIVE.

ON THE DOOR, THE USUAL RULES: THERE'S A $6 FINE FOR LIGHTING FIREWORKS IN THE ROOM, AND RADIOACTIVE WEAPONS ARE NOT ALLOWED IN THE HOSTEL.

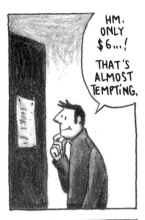

HM. ONLY $6...! THAT'S ALMOST TEMPTING.

THE HOSTEL IS LOCATED IN THE FORMER EUROPEAN ENCLAVE. SET BACK FROM THE CITY HUBBUB, IT'S THE PERFECT PLACE FOR A QUIET STROLL.

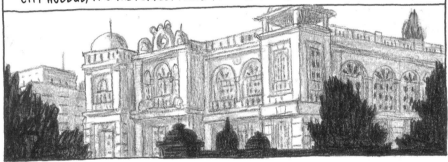

I'M QUICKLY ACCOSTED BY A CHINESE STUDENT.

HE OFFERS TO JOIN ME SO WE CAN GET TO KNOW EACH OTHER. I'M NOT SURE... HE SPEAKS ENGLISH LIKE A SPANISH COW!

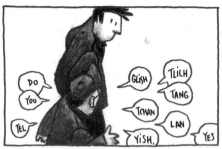

TO MAKE OUT A FEW FAMILIAR SOUNDS AND WORDS, I HAVE TO PAY CONSTANT ATTENTION AND MAKE HIM REPEAT EVERY SENTENCE AT LEAST THREE TIMES.

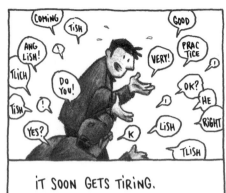

IT SOON GETS TIRING.

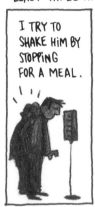

I TRY TO SHAKE HIM BY STOPPING FOR A MEAL.

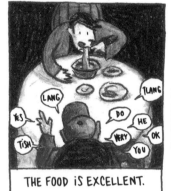

THE FOOD IS EXCELLENT.

AFTER A WHILE, MY ATTENTION STRAYS AND I WATCH TWO WORKERS BEHIND MY TALKATIVE COMPANION, UNBLOCKING SEWER DRAINS WITH A BAMBOO STICK.

I SUDDENLY REALIZE THEY'RE NOT WORKERS AT ALL, BUT TWO COOKS FROM THE RESTAURANT.

HM.

AFTER MUCH EFFORT, I MANAGE TO GRASP THAT HE'S STUDYING ENGLISH AND LOOKING FOR OPPORTUNITIES TO PRACTICE.

AND YET HE HARDLY LISTENS TO WHAT I SAY. I'VE BEEN ANSWERING IN FRENCH FOR A WHILE AND HE DOESN'T SEEM TO NOTICE.

CERTES.

HE OFFERS TO GIVE ME A TOUR OF THE CITY.

I SAY NO, POLITELY AT FIRST...

NO, NO THANK YOU.

BUT HE REFUSES TO GET THE MESSAGE, SO I MAKE MYSELF PERFECTLY CLEAR...

FUCK OFF!

HE LEAVES ME FOR ANOTHER PASSING TOURIST.

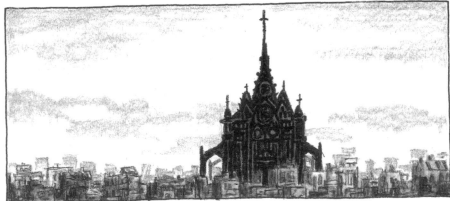

I COME ACROSS THE SACRÉ COEUR CATHEDRAL, LOST IN A LABYRINTH OF ALLEYS...

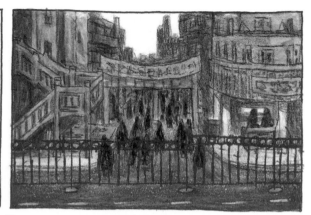

THE MARKETS SELL JUST ABOUT EVERYTHING THAT MOVES
...
CATS, FOR INSTANCE

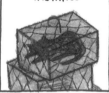

HA HA HA

PASSING BY A FANCY RESTAURANT, I SEE AN OSTRICH IN THE KITCHEN.

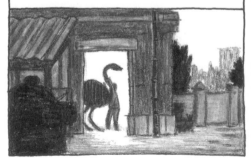

HOW'S THE OSTRICH... IS IT FRESH?

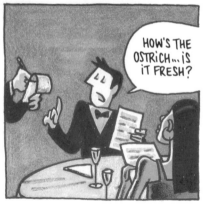

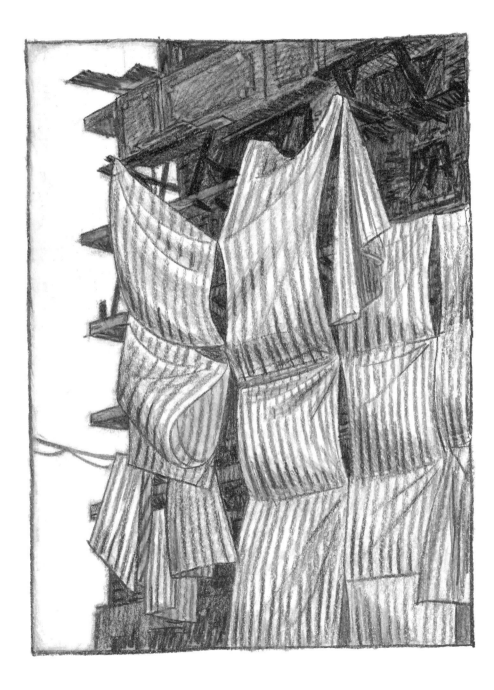

I LOOK (UNSUCCESSFULLY) BEHIND THE FRIENDSHIP STORE FOR A CHRISTIAN CEMETERY, THE SUPPOSED BURIAL SITE OF A NUMBER OF GIRLS KILLED BY CANADIAN NUNS.

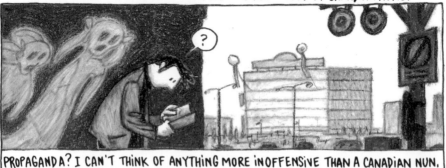

PROPAGANDA? I CAN'T THINK OF ANYTHING MORE INOFFENSIVE THAN A CANADIAN NUN.

IN THE PUBLIC TOILETS, THE MOOD IS CONTEMPLATIVE.

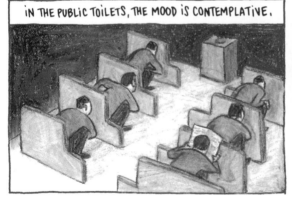

BY WAY OF AN ALTAR, THERE'S A SINK. I CLEANSE MY HANDS.

MY DEAR BROTHERS ...

POUR OUT YOUR SINS ... UNBURDEN YOUR-SELVES ...

I END THE DAY IN A BAR, DRINKING TSING TAO WITH A TOURIST.

HE'S AN ENGLISH CANADIAN WHO SPEAKS FRENCH WELL (A RARITY) AND INSISTS ON DOING SO WITH ME.

PREDICTABLY, THE CONVERSATION TURNS TO CANADA'S ONLY NATIONAL ISSUE: CULTURAL IDENTITY.

I BRING UP THE KILLER NUNS TO CHANGE THE SUB-JECT, BUT HE KEEPS ON.

SINCE HE SEEMS REASONABLE ENOUGH, I TELL HIM WHAT I REALLY THINK.

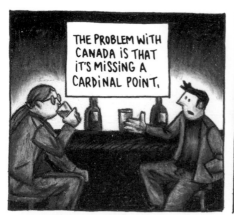

THE PROBLEM WITH CANADA IS THAT IT'S MISSING A CARDINAL POINT.

THE SOUTH IS OK, EVERYONE'S GLUED TO THE BORDER. EAST AND WEST ARE FINE TOO... BUT THE NORTH, NO ONE REALLY KNOWS WHERE IT ENDS!

HUDSON BAY? THE NORTH WEST TERRITORIES? THE ARCTIC CIRCLE? BAFFIN ISLAND? AFTER THAT, IT'S ALL ICE. YOU CAN'T EVEN TELL IF THERE'S GROUND UNDERFOOT!

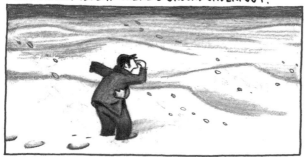

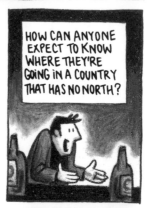

HOW CAN ANYONE EXPECT TO KNOW WHERE THEY'RE GOING IN A COUNTRY THAT HAS NO NORTH?

THE PROBLEM DOESN'T EXIST ANYWHERE ELSE... FRANCE EVEN HAS AN ADMINI- STRATIVE REGION CALLED "THE NORTH".

IF YOU ASK ME, CANADA NEEDS TO REDRAW ITS NORTHERN BORDER SO PEOPLE CAN SITUATE THEMSELVES, PSYCHOLOGICALLY SPEAKING.

I HEAD BACK,
PRETTY LIT, AND
STOP FOR A LONG
TIME TO ADMIRE
THE BANYANS THAT
LINE THE STREET,
BLENDING INTO THE
WARM EVENING
HAZE IN THE
DISTANCE.

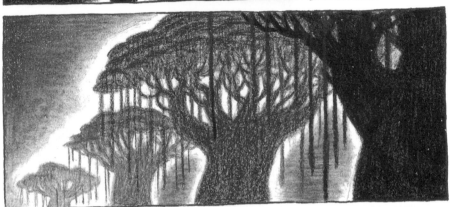

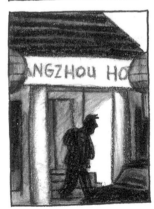

HELLO
YOU!

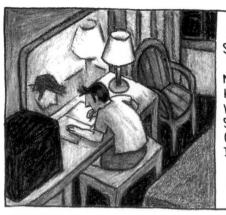

IF ONLY THE STUDIO HAD BEEN IN CANTON, MY STAY WOULD HAVE BEEN A WHOLE OTHER STORY. IT'S A CITY I THINK I COULD HAVE GROWN ATTACHED TO.

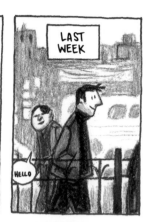

LAST WEEK

HELLO

TODAY, THE BOSS IS INVITING ME OUT TO LUNCH. HE'S LEAVING FOR THE WEEK AND WANTS TO THANK ME FOR MY WORK.

HE'S A TALL MAN, QUITE ELEGANT. HE GETS ALONG WELL WITH HIS EMPLOYEES EVEN THOUGH, TO HEAR THEM TELL IT, HE'S A LOUSY MANAGER.

BUT HE MUST BE ENTERTAINING. PEOPLE LISTEN WHEN HE TALKS AND LAUGHTER REGULARLY BREAKS OUT AROUND HIM.

NEEDLESS TO SAY, I DON'T UNDERSTAND A WORD... I CAN ONLY GRASP THE FORM: THE RHYTHM, INTONATION, PAUSES, ETC...

AND STRANGELY ENOUGH, I'M JUST ABOUT LAUGHING MYSELF.

IT'S A PLEASURE TO HEAR HIM TELL A STORY: THE RISING TENSION, THE PERFECTLY TIMED SILENCE THAT LEAVES THE LISTENER HANGING AND THE PUNCH LINE THAT DROPS CLEAN ...

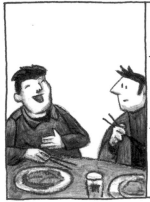

DESPITE THE MAJOR DIFFERENCES THAT SEPARATE EAST AND WEST, I THINK WE SHARE THE SAME NARRATIVE TECHNIQUES WHEN IT COMES TO SPOKEN LANGUAGE.

THAT MAKES ONE THING WE HAVE IN COMMON,

TO LEARN MORE ABOUT CHINESE HUMOR, I CONVINCE AN ANIMATOR TO TELL ME A JOKE...

A WEALTHY MANDARIN THREW A PARTY AND BOASTED THAT HE COULD GIVE HIS GUESTS EVERYTHING BUT THE MOON.

SUDDENLY A SERVANT CAME IN TO SAY THERE WASN'T ENOUGH WOOD FOR THE FIRE,

AND SO THE MANDARIN SAID: "EVERYTHING BUT THE MOON AND FIREWOOD."

HA HA HA HA HA

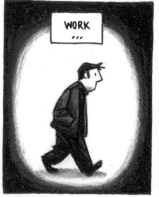

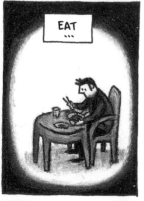

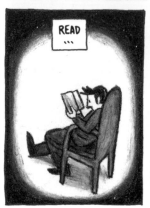

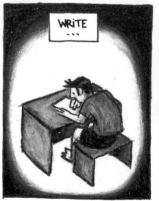

DAYS COME AND GO, ALL SO ALIKE THAT I DECIDE TO TRY AN EXPERIMENT:

PUSH THE SIMILARI-
TY TO THE EXTREME
IN ORDER TO GET
TWO DAYS THAT
ARE PERFECTLY
IDENTICAL.

THE GOAL IS TO SEE IF
IDENTICAL CONTEXTS PRO-
DUCE IDENTICAL THOUGHTS.

ARTISTS WHO INK THEIR
OWN PENCILS KNOW THE
FEELING...

GOING OVER THE SAME LINES,
THE SAME THOUGHTS
RESURFACE.

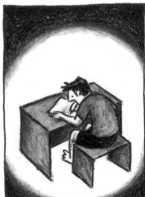

IN THE END,
IT DOESN'T
WORK...

THOUGHTS
JUST AREN'T
THAT EASY
TO KEEP UN-
DER CONTROL.

IT
FIGURES
...
OH WELL,
AT LEAST
THAT
MAKES
ONE DAY
LESS LEFT
TO GO.

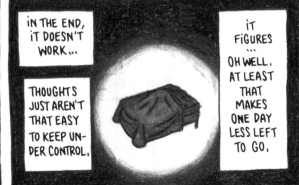

MORNINGS, I WALK ALONG A STREET WHERE PEOPLE LAY OUT THEIR DIPLOMAS, WAITING FOR JOB OFFERS.

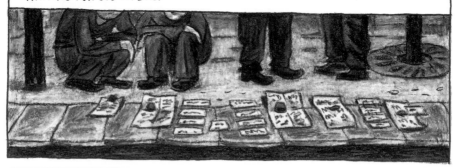

EVENINGS, THEY'RE OFTEN REPLACED BY A BARBER WHO GIVES WORKERS FROM A CONSTRUCTION SITE NEXT DOOR A TRIM, ONE AFTER THE OTHER.

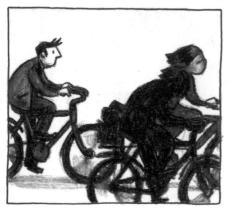

THE POWER IS OUT AT THE GYM. THE CLIENTS LEAVE, DISAPPOINTED...

I INSIST ON GOING UP. IT'S STILL LIGHT OUT AND AFTER ALL, THE MACHINES WORK ON MUSCLE POWER...

IN THE LOCKER ROOM, I COME ACROSS A STRANGELY SHAPED OLD MAN.

JUST LIKE A RING CAN DEFORM A FINGER WITH TIME, HIS BELT SEEMS TO HAVE DUG A HOLLOW INTO HIS WAIST OVER THE YEARS.

MAKES YOU WONDER IF WE ADJUST TO OUR CLOTHES MORE THAN THEY DO TO US,

I'M ON MY OWN, AND IT'S NOT UNPLEASANT. ESPECIALLY SINCE I DON'T HAVE TO LISTEN TO WHITNEY HOUSTON YOWL THROUGH THE SPEAKERS IN A NEVER-ENDING LOOP...

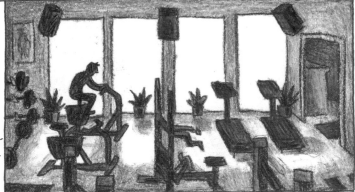

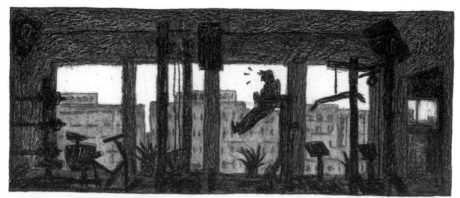

NIGHT FALLS SLOWLY, AND THE GUY WHO USUALLY MANAGES THE JUICE BAR SETS OUT DOZENS OF CANDLES IN THE GYM,

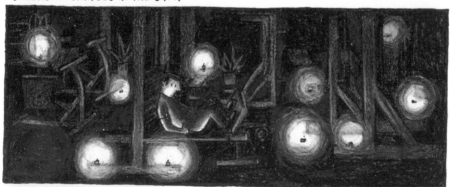

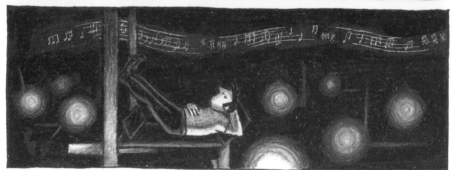

AND TO ADD TO THE MAGIC OF THIS UNFORGETTABLE MOMENT, I HEAR HIM IN A ROOM NEXT DOOR, SINGING A LILTING SONG THAT SOUNDS LIKE IT'S OUT OF A FAIRYTALE,

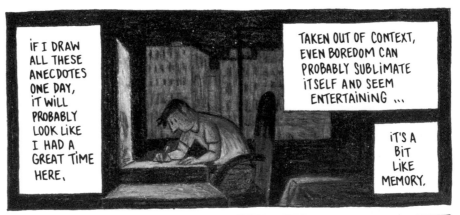

IF I DRAW ALL THESE ANECDOTES ONE DAY, IT WILL PROBABLY LOOK LIKE I HAD A GREAT TIME HERE.

TAKEN OUT OF CONTEXT, EVEN BOREDOM CAN PROBABLY SUBLIMATE ITSELF AND SEEM ENTERTAINING ...

IT'S A BIT LIKE MEMORY.

THE LAST DAY IS QUIET. THERE'S NOT MUCH TO DO.

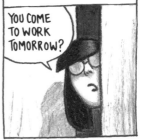

AND LIKE EVERY FRIDAY, MY TRANSLATOR COMES TO ASK:

YOU COME TO WORK TOMORROW?

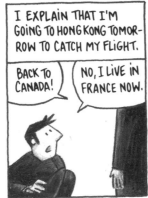

I EXPLAIN THAT I'M GOING TO HONG KONG TOMOR- ROW TO CATCH MY FLIGHT.

BACK TO CANADA!

NO, I LIVE IN FRANCE NOW.

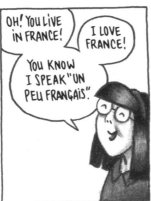

OH! YOU LIVE IN FRANCE!

I LOVE FRANCE!

YOU KNOW I SPEAK "UN PEU FRANÇAIS".

IN OUR LAST HALF HOUR TOGETHER, WE GET TO KNOW EACH OTHER.

BUT ON HER WAY OUT, SHE LEAVES A WAIST-HIGH PILE OF SEQUENCES FOR ME TO CHECK.

I WORK INTO THE NIGHT.

WHEN I'M DONE, THE STUDIO IS EMPTY.

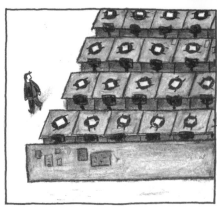

HEY!

LUCKILY THE JANITOR WHO LIVES ON THE FLOOR HEARS ME AND COMES TO LET ME OUT.

ON THE 3RD FLOOR, THE COOK FROM THE RESTAURANT STEPS IN AND SMILES AT ME...

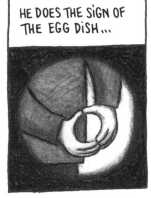

HE DOES THE SIGN OF THE EGG DISH...

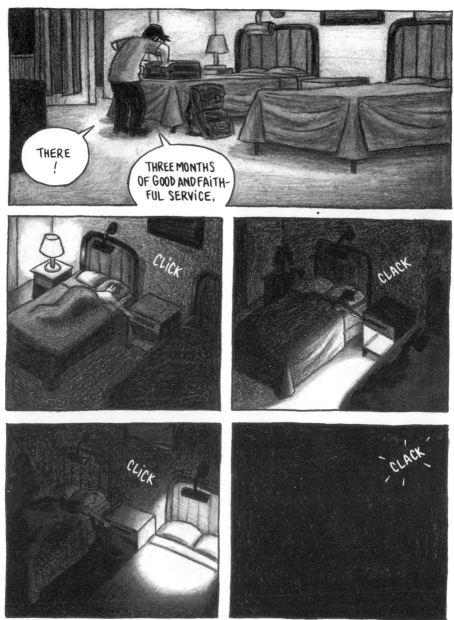

DELISLE.